The Campus History Series

FENN COLLEGE

CLEVELAND STATE UNIVERSITY LIBRARY

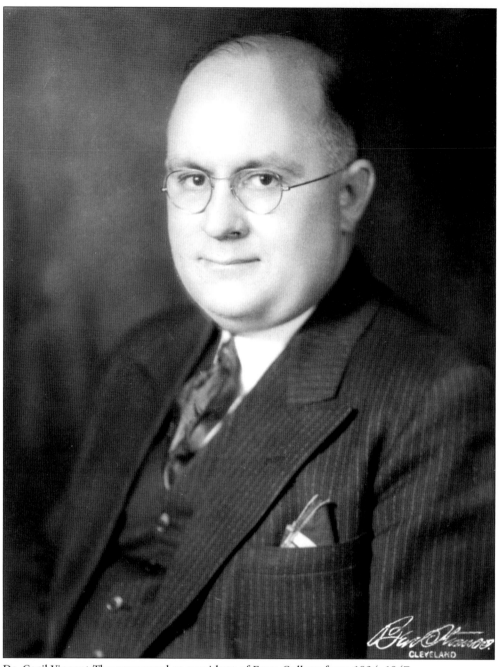

Dr. Cecil Vincent Thomas served as president of Fenn College from 1934–1947.

The Campus History Series

FENN COLLEGE

CLEVELAND STATE UNIVERSITY LIBRARY

ARCADIA

Published by Arcadia Publishing
Charleston SC, Chicago IL, Portsmouth NH, San Francisco CA

Printed in Great Britain

Library of Congress Catalog Card Number: 2004116409

For all general information contact Arcadia Publishing at:
Telephone 843-853-2070
Fax 843-853-0044
E-mail sales@arcadiapublishing.com
For customer service and orders:
Toll-Free 1-888-313-2665

Visit us on the internet at http://www.arcadiapublishing.com

Photographs appear courtesy of the Cleveland State University Archives
and the Cleveland State University Library Special Collections Area.

Please note that throughout the book, dates in parenthesis following a person's name indicate
the person's years of service at Fenn College, and for some this also includes their time at
Cleveland State University.

CONTENTS

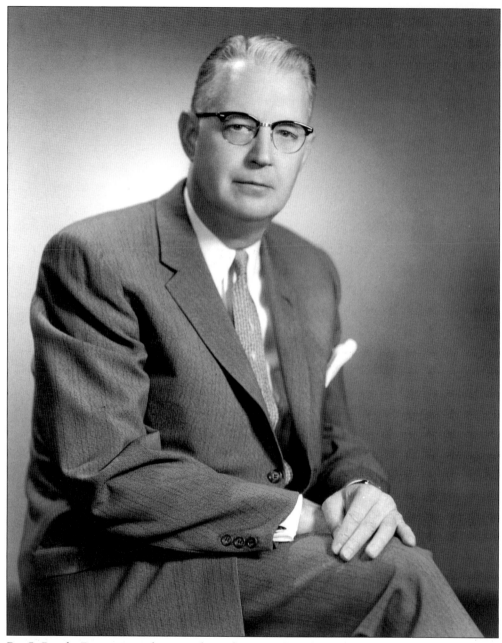

Dr. G. Brooks Earnest served as president of Fenn College from 1952–1965.

INTRODUCTION

In 1923 Cleveland, Ohio, was the sixth largest city in the country and a major center of industry and commerce. When Cleveland's newest college first started offering classes that September, Dr. Cecil Vincent Thomas had solid reasons to be confident about its future. As executive director of the Cleveland YMCA, he led both one of the strongest YMCA programs in the country and a successful educational program that for more than 50 years had helped thousands of students complete their secondary schooling or learn technical and business skills.

Fenn College, the predecessor of Cleveland State University, was one of over 30 private colleges that grew out of the educational programs established by the YMCA in various cities throughout the United States during the late 19th and early 20th century. Fenn was a small urban commuter college located less than three miles down Euclid Avenue from two nationally-recognized private universities. Its success was the result of its administration and faculty's belief in and dedication to the idea of providing a low-cost, quality college education to students who otherwise would not have had the opportunity.

The education program of the Cleveland YMCA began in 1881, reflective of the YMCA's shift in emphasis from reformation to character development. In 1906 the Cleveland YMCA combined operations of its newly created day school program with its evening school under the name of the Association Institute. Four separate day schools were created in 1909: the School of Commerce and Finance, the Technical School, the Preparatory School, and the Special School, which was dropped in 1913. The schools became co-ed in 1918. In 1921 the YMCA's educational branch was re-named the Cleveland School of Technology.

Finding a need, the YMCA offered its first college credit classes in engineering and business administration in 1923. Classes were held at the Central YMCA Building on Prospect Avenue and East 22nd Street and three converted residences adjacent to the Central YMCA: the Johnson Building, the Edwards Building, and the Medical Library Building. Two significant events marked 1927: the first college degrees were awarded, and planning began for a junior college program that became the Nash Junior College in 1931. In 1928 the first building built for the college, the Fenn Building, was constructed adjacent to the YMCA behind the Johnson Building.

The need to achieve accreditation led the YMCA to reorganize its educational program in 1929. Also at this time the school's name was changed to Fenn College to honor Sereno Peck Fenn, who had served the Cleveland YMCA as president and board director for over 50 years. College lore holds that another reason for the name change was that the student body generally wanted a more distinguished sounding name on their diplomas than YMCA.

The Preparatory School and Nash Junior College ceased operations in 1935 as a School of Arts and Sciences was added to the Engineering and Business Administration schools. In 1937 Fenn purchased the National Town and Country Club Building at Euclid Avenue and East 24th Street. Renamed Fenn Tower, it not only provided needed classroom and office space, it also gave Fenn a more prestigious "Euclid Avenue" address. Fenn's reputation was further enhanced when it received accreditation from the North Central Association in 1940.

Dr. Cecil Vincent Thomas, who served simultaneously as the YMCA's executive director and as Fenn's first president, was responsible for much of Fenn's early growth and development. During Dr. Edward Hodnett's administration, Fenn built Foster Hall, a mechanical engineering building financed by a donation from Cleveland entrepreneur Claude Foster, and at the recommendation of the North Central Association, established operations separate from the YMCA. Fenn expanded again under Dr. G. Brooks Earnest, purchasing the Ohio Motors Building on East 24th Street. Renovated for classroom use, the building was dedicated in honor of Fenn Trustees Chairman Charles Stilwell.

Throughout its history Fenn never operated with a deficit. However, by 1963 increasing operating costs and competition from the new community college had placed Fenn in severe financial straits. That year, Fenn released "A Plan for Unified Higher Education in Cleveland—Northeast Ohio," urging the state to develop a state university in Cleveland using Fenn College as its nucleus. On December 18, 1964, Governor James Rhodes signed legislation creating Ohio's seventh state university, and on September 1, 1965, Fenn College formally became Cleveland State University.

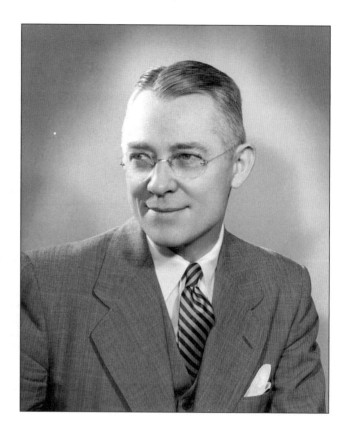

Dr. Edward Hodnett served as president of Fenn College from 1948–1951.

8

One

THE CAMPUS

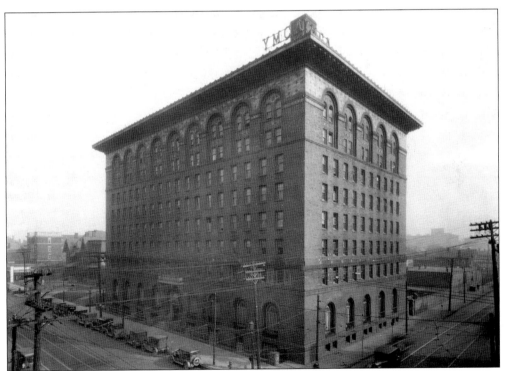

The Central YMCA on the southeast corner of Prospect Avenue and East 22nd Street was home to the Cleveland YMCA's education program. It is shown here around the time of the start of its college-level program in 1923, when the "Y" housed two classrooms and two laboratories.

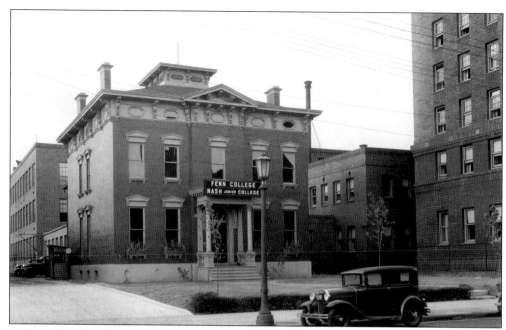

The Johnson Building was located next to the Central YMCA on Prospect Avenue. First used in 1922, it had six classrooms, as well as offices. During Fenn's early years its front entrance was used as a symbol for the college. In this photograph from *c.* 1931 the YMCA is on the right, and the Fenn Building is behind the Johnson Building.

The Edwards Building was the middle of three former residences on Prospect Avenue converted by the YMCA for their education program. It had 10 classrooms. In this photograph from *c.* 1931 the Medical Building can be seen on the left and the Johnson and Fenn Buildings on the right.

The YMCA acquired the Medical Library Building in 1926. The easternmost of the three former residences on Prospect Avenue converted to classrooms used by the YMCA, it provided 12 classrooms, a 250-seat auditorium, and an electrical laboratory in the basement.

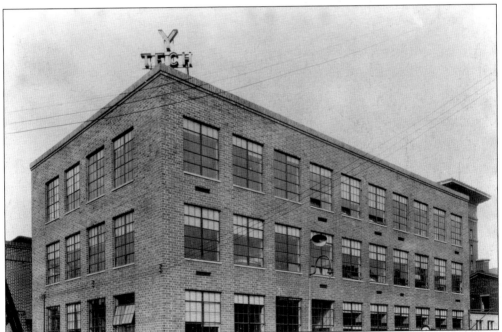

The first building to be constructed for the college, the Fenn Building housed eight engineering and science laboratories and 19 classrooms. It opened in 1928 and stood behind the Johnson Building on Prospect Avenue, next to the Central YMCA. This picture from *c.* 1929 shows the electric Y-TECH sign on the southeast corner.

This *c.* 1930 image looks east along the south side of Prospect Avenue (from in front of the Central YMCA) at the three former residences, the Johnson, the Edwards, and the Medical Library Buildings, that had been converted by the YMCA for their education program.

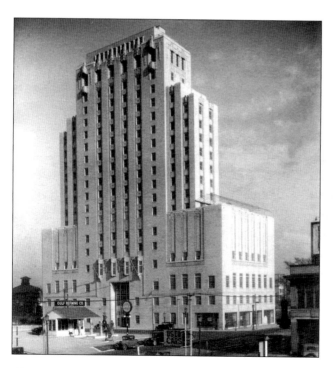

The National Town and Country Club hosted only one event in its new home at Euclid Avenue and East 24th Street before going bankrupt during the Depression. Built in 1929, the building stood vacant for years until Fenn College purchased the building from the Reconstruction Finance Corporation for the price of the delinquent taxes owed on the building in 1937. When Fenn moved in 1939, it not only had a new home but also a more prestigious address.

When Fenn's "Campus in the Clouds" opened in 1938 only two other schools in the U.S. had skyscrapers on their campuses: Pitt's Cathedral of Learning and Northwestern's downtown branch in Chicago. The new tower gave Fenn an additional 2 million cubic feet of space for classrooms, administrative offices, a library, a ballroom, a gymnasium, a swimming pool, and dormitories. The photograph shows the tower around the time the college purchased it.

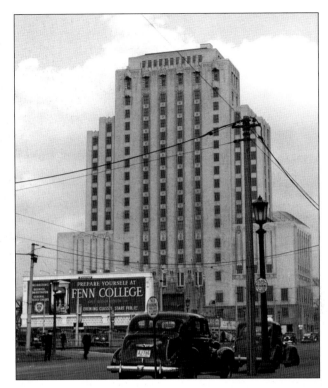

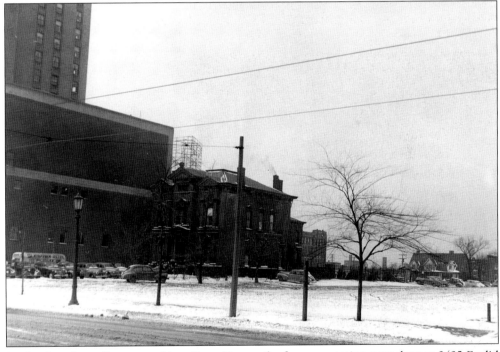

By the time the college moved into Fenn Tower, the former mansion next door at 2425 Euclid Avenue had been converted to apartments with an automobile repair shop at the rear. The mansion was razed just before construction began on Foster Hall, around 1947.

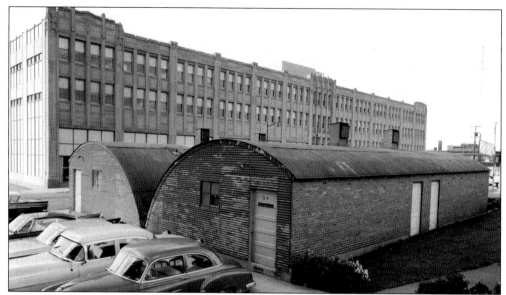

Like many other schools, Fenn saw a sharp increase in enrollment following World War II as returning veterans took advantage of provisions in the G.I. Bill to return to school. To help alleviate overcrowded conditions, Fenn built two Quonset huts for classroom use on East 24th Street, just north of Fenn Tower. The Quonsets are seen here from the back of Fenn Tower in 1960.

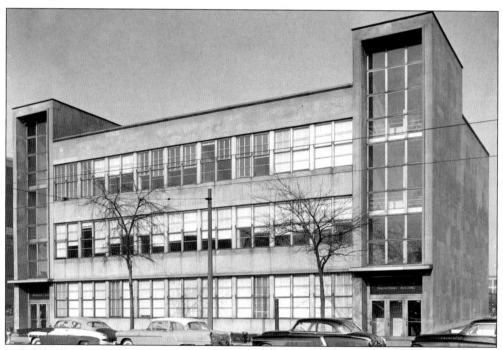

Dedicated in 1949, the three-story Claude Foster Engineering Building was located east of Fenn Tower on Euclid Avenue. The 350,000-square-foot steel and concrete slab building, shown here in 1958, was a gift of Cleveland industrialist Claude Foster. It contained eight classrooms, two drawing rooms, two offices, and a production laboratory adjoined by a shop-type tool crib, a locker room, and a washroom.

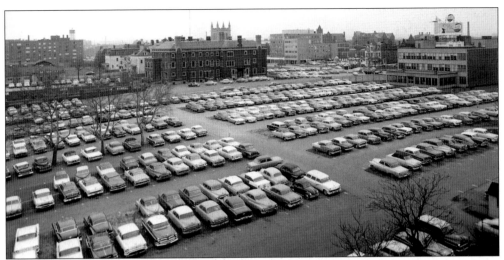

A common concern for all commuter schools is having enough nearby parking for students, faculty, and staff. Fenn's main parking lot stretched from East 24th Street to the Cleveland Automobile Club and between Euclid and Chester Avenue. Today it is the site of CSU's Physical Education building, Intramural Sports Center, and the Health Sciences building.

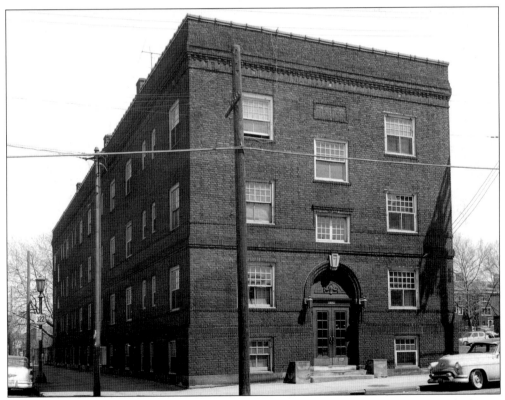

The White Apartment Building stood at the southeast corner of East 24th Street and Chester Avenue, just north of Sadd's Restaurant. In September of 1954 Fenn purchased the apartment building for $270,000. Plans to convert it for dormitory use were dropped when the widening of Chester Avenue for the new Innerbelt freeway necessitated that the apartments be razed.

15

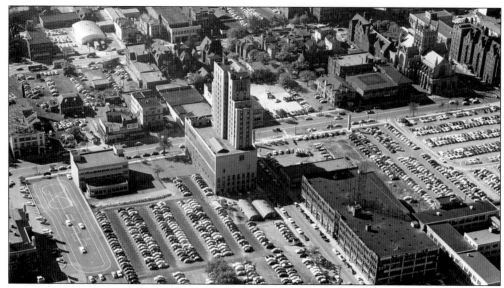

This view looks south at the Fenn College campus between Chester Avenue (bottom) and Euclid Avenue shortly before construction for the Innerbelt. In addition to Fenn Tower and Foster Hall there is the Ohio Motors Building, the White Apartment Building, Sadd's Restaurant on East 24th Street, and the Cleveland Automobile Club (AAA), partially seen to the east.

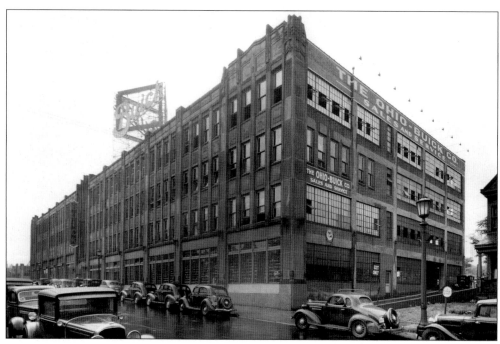

Located on the east side of East 24th Street between Euclid and Chester Avenue, the Ohio Motors Building had a car dealership on the first floor, an automobile service department on the second, and offices on the third and fourth floors. This 1937 image taken from Chester shows the Ohio-Buick Co. dealership.

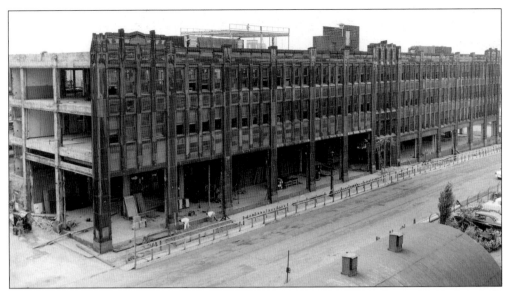

In 1956 Fenn began a $2 million renovation of the Ohio Motors Building. Plans were for it to house five engineering departments, a new library, classrooms, dining facilities, and student activities and recreation areas. This 1958 photograph shows the extent of the remodeling effort.

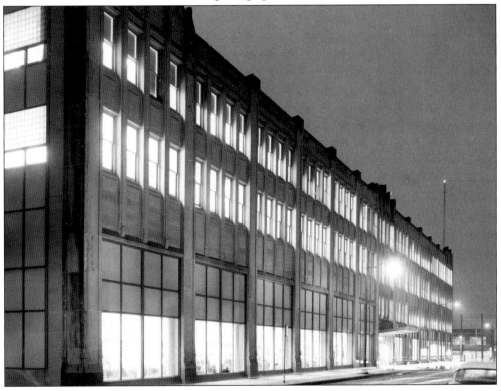

The Engineering and Science Building opened in the fall of 1959. On January 29, 1960, it was formally dedicated as Stilwell Hall in honor of Fenn College Trustee Charles J. Stilwell, who served as president of the board for 16 years and who headed the drive to raise the funds to purchase the building. The image shows Stilwell Hall on the evening of the dedication program.

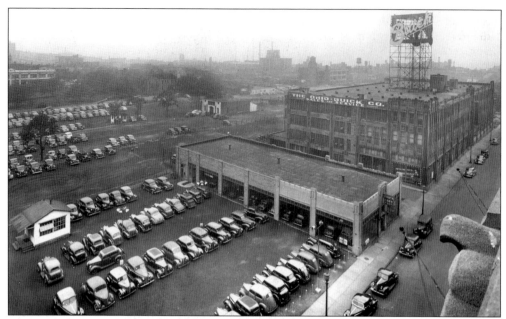

The northwest corner of Euclid Avenue and East 24th Street was the site for both gas stations and used car lots. This 1942 picture looking west from Fenn Tower shows Ohio Motors' used car lot. After Fenn's purchase of the Ohio Motors Building it became the Lou Cohen Used Car Co.

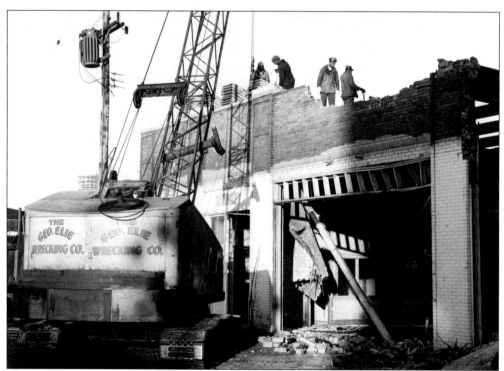

Fenn purchased the Lou Cohen Automobile Co. property in 1963 and razed it in January 1964. Originally the college intended to use the land for a new administration building. Today it is the site of the Science Building, the first building built for CSU.

Located on the east side of East 24th Street, just south of the White Apartments, Sadd's was a popular place for Fenn Tower dorm residents to eat on Sunday evenings. Here Fenn President G. Brooks Earnest receives the keys from George Sadd following Fenn's purchase of the building in January 1961.

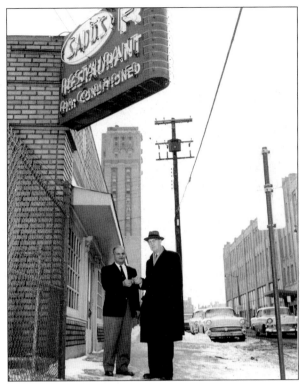

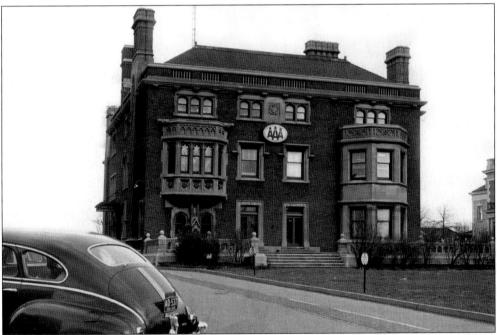

The Cleveland affiliate of the American Automobile Association, seen in this 1950 photograph, was located in the historical Samuel Mather Mansion at 2605 Euclid Avenue at the eastern end of Fenn's campus. CSU later purchased the mansion. Today it is home to the CSU Alumni Association and Advancement Office.

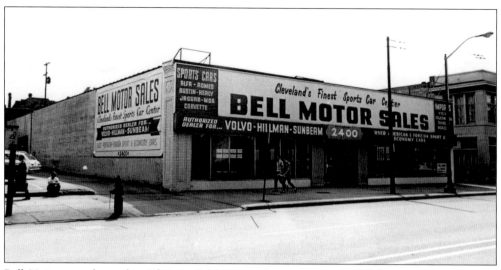

Bell Motors was located at 2400 Euclid Avenue, directly across Euclid from Fenn Tower. Bell Motors featured new Volvo, Hillman, and Sunbeam sport cars. The building would be later purchased by Cleveland State University for use as its undergraduate library and bookstore.

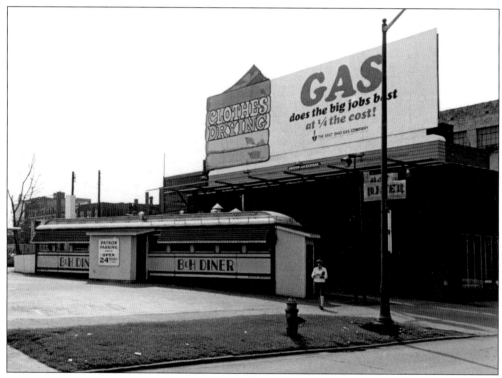

The B&H Diner was a classic streetcar diner located at 2504 Euclid Avenue, across from the Cleveland Automobile Club. Shown here in 1965, the B&H, like Sadd's, was a popular eating place for Fenn dorm residents, especially on Sunday evenings.

Two

GROWTH AND
DEVELOPMENT
1923–1941

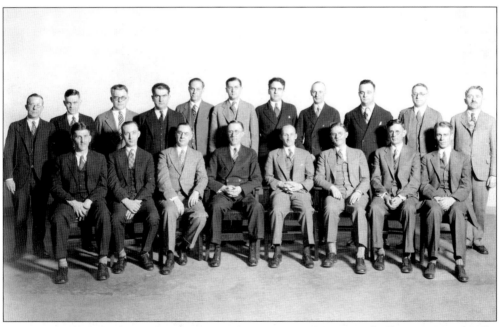

This image shows School of Commerce, Accounting and Finance faculty in 1928. Faculty members taught five classes each term in both day and evening divisions, as well as on Saturday mornings. George Simon is standing at the far left next to Vance Chamberlain, who taught at the school between 1918 and 1969. Leyton Carter, who later was a college trustee, is fourth from the left. Dean Stacey Black is fourth from the right in the front row.

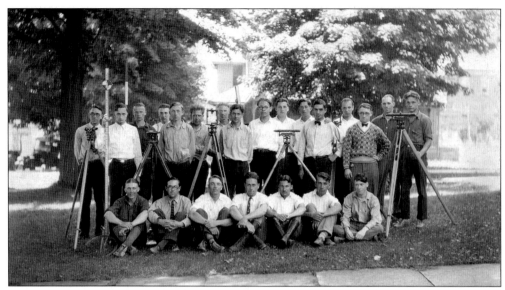

A highlight for Fenn freshman engineering students was the surveying camp held in Hiram, Ohio, where students undertook extensive field work. Here Maurice Nichols (1925–1937), instructor of surveying, standing on the far left, poses with the students of the 1927 camp.

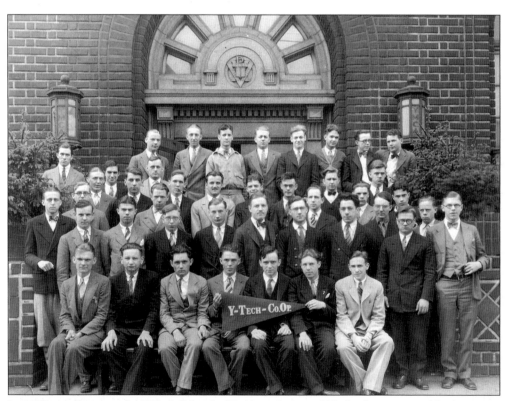

In 1928 enrollment at the Y-Tech School of Engineering was 132. Sophomores and juniors were divided into two groups that alternated every five weeks between classes and their co-operative education work assignments. Here Group "B" poses outside the Central YMCA.

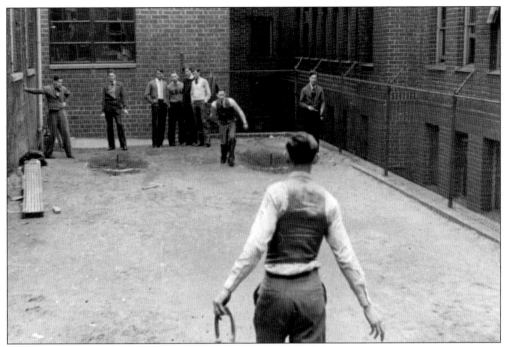

With the benefits of a YMCA on the campus Y-Tech students had various ways to spend their time between classes. One of them was at the horseshoe pit in the rear of the YMCA building next to the Fenn Building, as shown in this *c.* 1928 image.

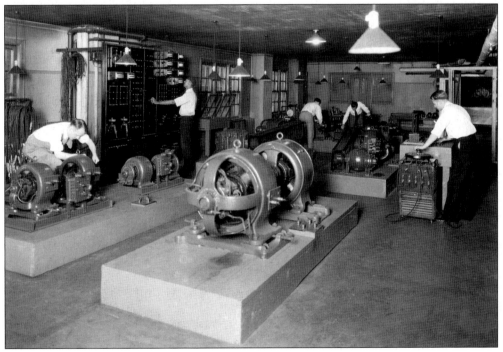

In this image electrical engineering students work in the basement electrical engineering laboratory of the Medical Library Building, *c.* 1929.

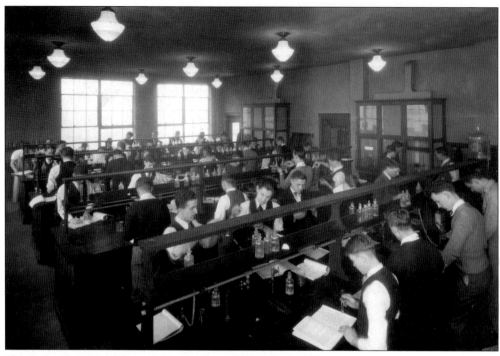

This is the chemistry laboratory in the Fenn Building, *c*. 1929.

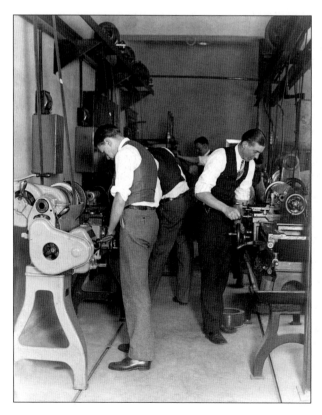

Mechanical and civil engineering students work at the machine tools used for making specimens to be tested in the Test Materials Lab in the Fenn Building, 1929.

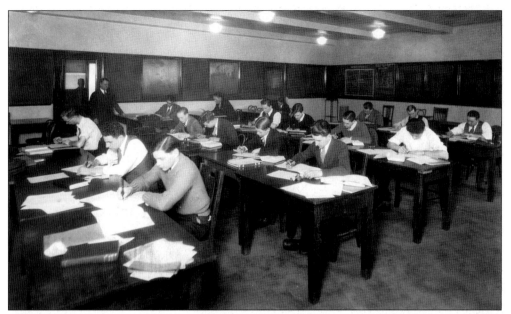

Students in George Hirst's 1930 accounting class included Howard Cunnan (B.B.A., 1935), in the gray sweater, first row; Thomas Dwyer (B.B.A., 1935), second row, right end; Norman Feldman (B.B.A., 1936), next to Mr. Dwyer; and Clifford Koehlke (B.B.A., 1935), third from the right. Mr. Dwyer later served as the college's assistant finance director.

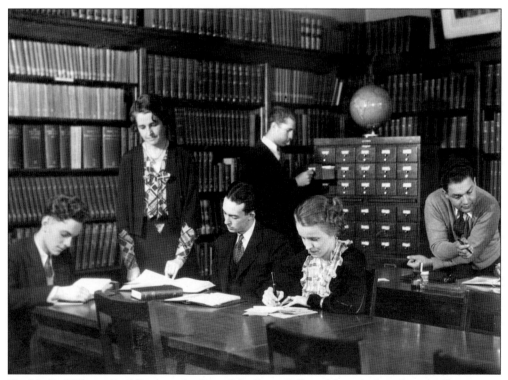

The Medical Library Building was the first of the Fenn College Library's three homes. The woman standing on the left is Elizabeth Willingham (1928–1937), the college librarian, c. 1930.

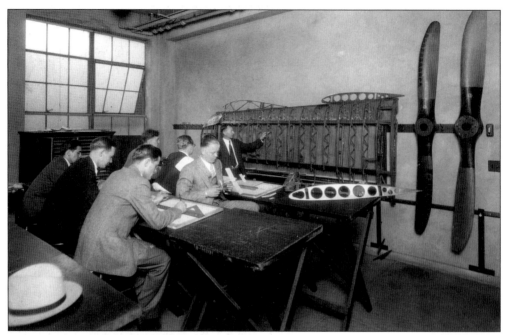

The Engineering School recognized the growing importance of the field of aeronautics and offered mechanical engineering majors courses in the fundamental principles of aerodynamics, as well as the design of airplane structures and engines. Here Samuel Ward (1929–1949), professor of mechanics and materials, discusses airplane wing design, *c.* 1930.

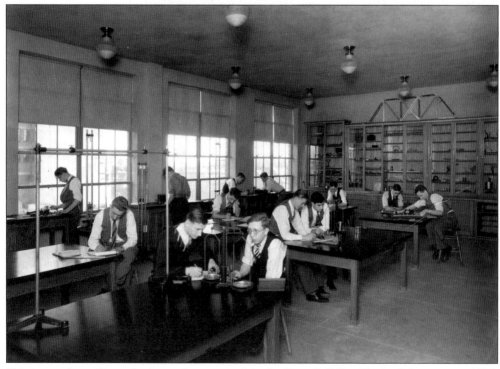

This image shows Fenn physics students at work in the Fenn Building Physics Laboratory, *c.* 1930.

The opening of the school year in September signaled the renewal of the rivalry between the freshman and sophomore classes. The annual competition included the "Flag Rush," Fenn's own variation of the game "Capture the Flag," held outside of the Medical Library Building on Prospect Avenue, 1931.

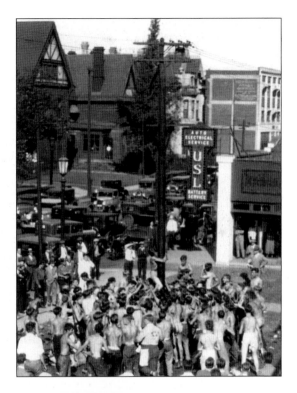

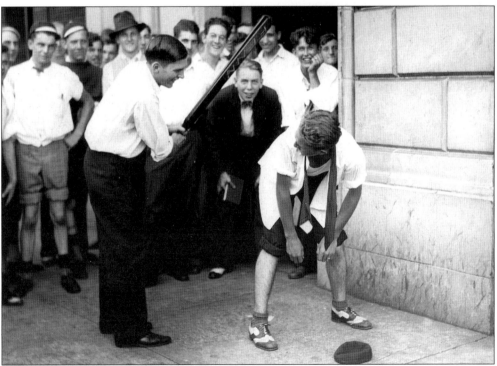

Upperclassman Raymond Kamp gives Robert Hech the traditional freshman warm welcome to Fenn College in September of 1931.

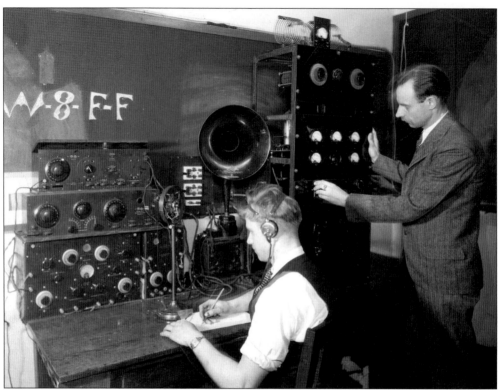

John Festak receives a radio message while Hoyt Scott, instructor of radio (1928–1931), adjusts the filament voltage on the transmitter tube of Fenn's new broadcasting station, W-8-F-F, in 1931.

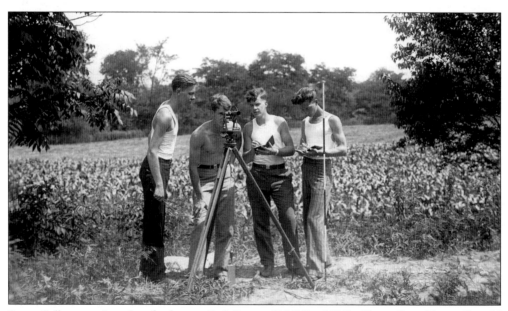

Fenn College engineering freshmen Carl Berge (B.S.E.E., 1935), Harry Donaldson, Donald Stroud (B.S.M.E., 1935), and Clarence Metzger practice their skills at the 1931 surveying camp at Hiram, Ohio.

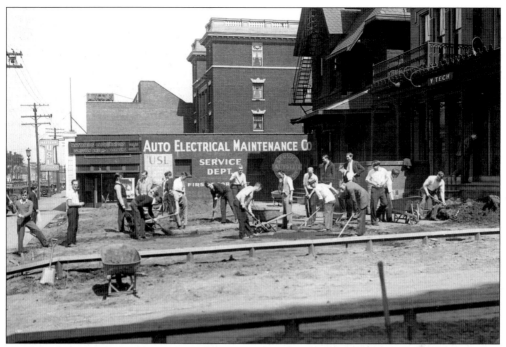

This image looks east along the south side of Prospect Avenue from in front of the Central YMCA at students and faculty members doing landscaping in front of the Johnson, Edwards, and Medical Library Buildings, 1931.

Ethel Hanavan addresses George Simon's Public Speaking course, c. 1931. Mr. Simon (1928–1965) is the fellow wearing glasses in the far corner of the room near the windows. After retiring from teaching in 1952 he was appointed the school's first archivist.

In 1932 the Cleveland YMCA revised its Preparatory School program to create Nash Junior College, which in turn became the Fenn College School of Arts and Sciences in 1934. Here the first class of Nash Junior College poses together outside the Central YMCA.

The original faculty members of Nash Junior College pose for a group photograph in 1932. From left to right they are as follows: Dr. Donald Tuttle, English; Walter Okonski, Physical Education; Courtney Anderson, Biology/English; Blanche Tolar, Math; Donald Super, History/Political Science; Dean Paul Williams; Millard Jordan, Economics/Psychology; Robert Mulhauser, Physics/Math; and Franz Tomich, French/German. In addition to their teaching duties, the faculty was also directly involved with recruiting new students, often visiting prospective students at their homes.

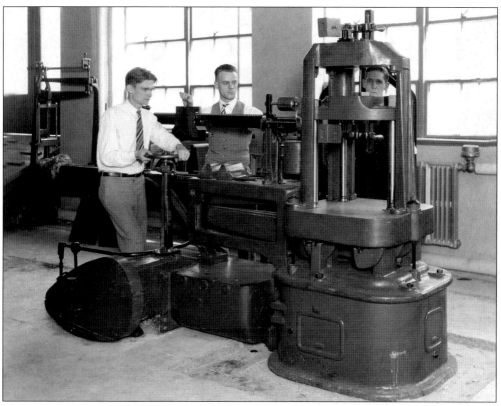

Fenn engineering students are pictured using the 100,000-pound Olsen Testing Machine in the Fenn Building's Testing and Materials Laboratory, *c.* 1933.

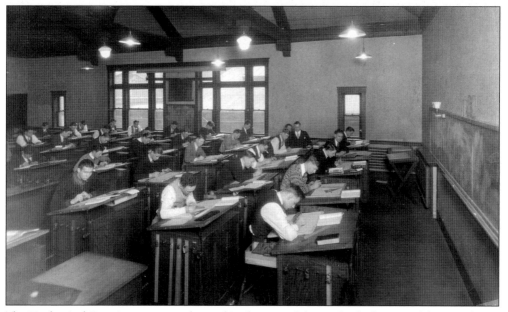

The Mechanical Drawing room was located in the rear of the Medical Library Building. Professor Virgil Hales is standing between the windows at the far end of the second row, 1934.

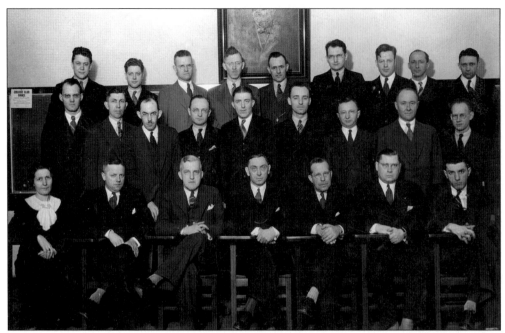

The 1934 Fenn College faculty are pictured as follows: (front) Blanche Tolar, William Davis, Paul Anders, Joseph Nichols, George Simon, Virgil Hales, and Hyman Lumar; (center) William Christian, Millard Jordan, Willis Hotchkiss, Donald Fabel, Joseph Kopas, Adolph Berger, Samuel Ward, Louis Hunt, and Joseph Margolis; (back) Charles Dilley, Donald Tuttle, Alex Rexion, Max Robinson, Charles Francis, Burl Bush, David MacAlpine, Lad Pasuit, and Randolph Randall.

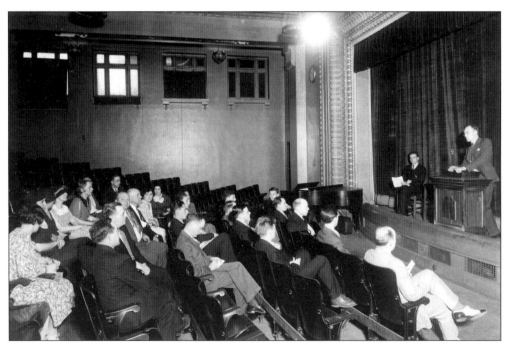

The public speaking class would meet in the Central YMCA Auditorium in order to give the student speakers an opportunity to give talks in different types of situations, c. 1935.

An article printed in the April 21, 1935, *Cincinnati Enquirer* was entitled "Cleveland Group Inspects Cincinnati; Sells Homemade Cakes to Pay Way Here." In the accompanying photograph Fenn students and faculty stand with city officials on the steps of City Hall. Among the city officials is City Manager Clarence Dykstra. Among the students on the trip are Josephine Costanzo, Joan Luton, Margaret Mulligan, and Mildred Yenchius.

Fenn registered its first victory ever in a dual track meet in 1936 defeating Hiram College, 68 1/3 to 61 2/3. Later that year Fenn finished fifth at the "Big-4 Invitational" meet with Case Institute of Technology, Western Reserve University, Baldwin-Wallace, Hiram College, and University of Toledo. Due to co-op schedules a number of Fenn trackmen over the years trained on their own, mailing in training logs to the Athletic Office.

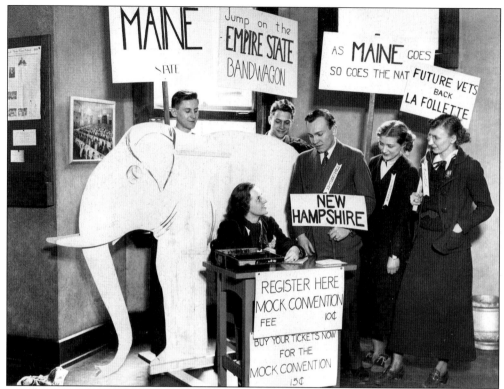

On May 6 and 7, 1936, the college held the first of two mock presidential nominating conventions. Shown at the convention's registration desk are Robert Herrman (B.B.A., 1939), Paul Dilley (B.A., 1939), Margaret Mulligan (B.A., 1939), Robert Bishop (B.B.A., 1939), Louise Kopes, and Ruth Tresnicka (B.A., 1938).

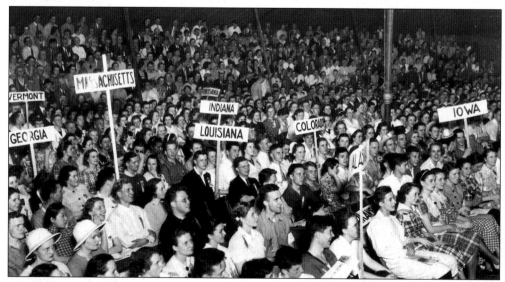

Delegates to Fenn College's first mock political nominating convention met on the evening of May 7, 1936 to select Senator Robert LaFollette of Wisconsin and Mayor Fiorello LaGuardia of New York City as their candidates for President and Vice President of the United States.

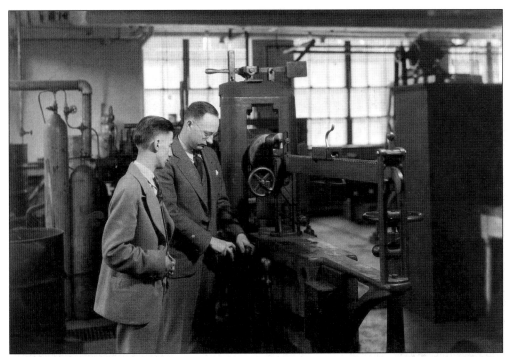

Mechanical Engineering Professor Donald Fabel (1928–1966) taught at Y-Tech and Fenn for 38 years and was founder and organizer of the Fenn Rifle Club. Here Dr. Fabel and James Fretz (B.M.E., 1936) inspect the machinery in the Fenn Building's Mechanical Engineering Laboratory, *c.* 1936.

Class changes meant crowded hallways as students moved from one classroom to another, as is shown in this evening school photograph of the Johnson Building in 1937.

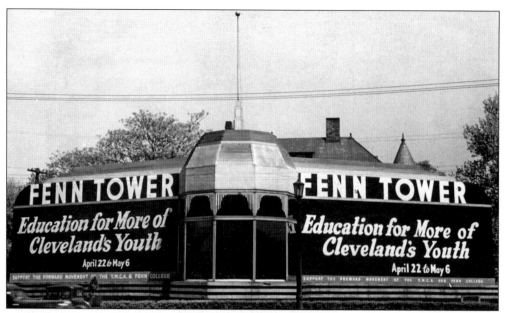

By 1936 Fenn's enrollment was nearly 2,000. Classes and laboratories were crammed into every available space, and class sizes were stretched beyond the point of maximum teaching efficiency. Once college trustees and the Cleveland YMCA decided to proceed with the purchase of the National Tower and Country Club, they needed to figure out how to finance it. By November 1937 they had gathered private and public pledges of almost $187,000.

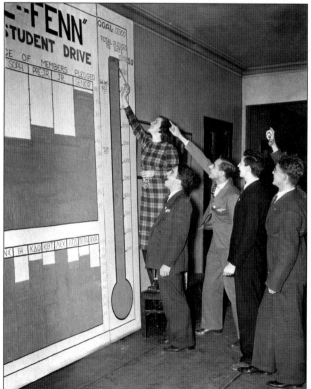

Showing their support of the college's efforts to acquire the National Town and Country Club building, Fenn students organized the "We-Fenn" drive to raise $11,800 during October of 1937. Tim Tatar (B.Ch.E., 1938), Denver Roth, William Bland (B.S.E., 1940), and Theodore Thomas (B.A., 1938) watch as Margaret Mulligan (B.A., 1939) paints in the chart to show that the drive went over top, raising a final total of $12,272.50.

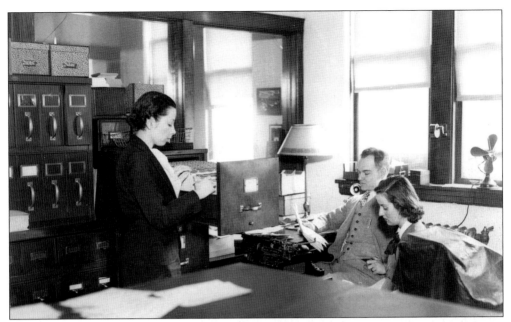

In this 1937 photograph Fenn College Registrar Dr. Walter Goetsch (1936–1946) gives dictation in his overcrowded "cubby-hole" office in the Johnson Building where four people regularly worked.

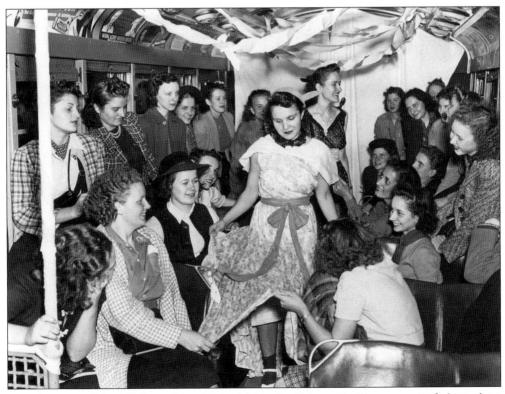

Dorothy Rossa (B.A., 1938) models a gown during the Gamma Nu Sigma sorority fashion show held onboard a Euclid Avenue streetcar, October 1938.

In 1939 Walter Schaefer (B.M.E., 1942), working with Physics Professor Willard Poppy, designed a Foucault Pendulum that still hangs in an air vent in Fenn Tower. The world's longest at the time of its construction, Schaefer used 211 feet of steel piano wire attached to a pointed needle-bearing unit on the 21st floor and a 40-pound lead weight at the bottom in the basement.

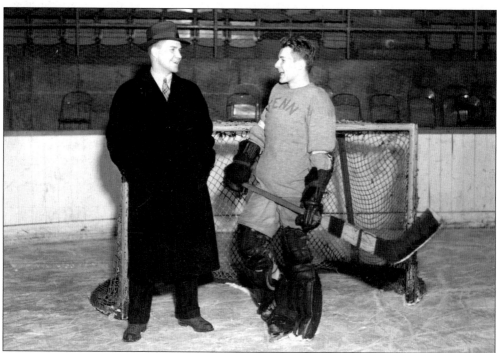

One of the more successful of Fenn's varsity sports programs was ice hockey. Cooperative Education Coordinator and Hockey Head Coach James Griswold (1938–1946) talks with freshman goalie Joseph Zimmerman on the ice at the Cleveland Arena, where the team played its home games, 1940.

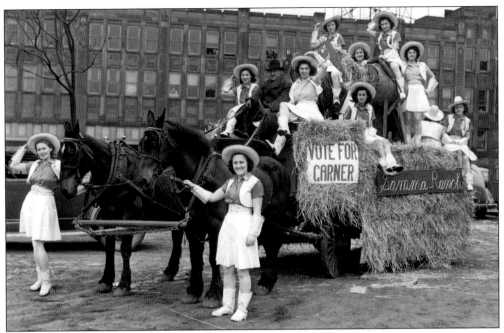

On April 19 and 20, 1940, Fenn held its second mock presidential nominating convention in the Dyke Auditorium. The keynote speaker was Congressman-at-large Stephen Young, who urged continuation for President Roosevelt's New Deal. Here members of the Gamma Nu Sigma sorority await their turn in the convention parade.

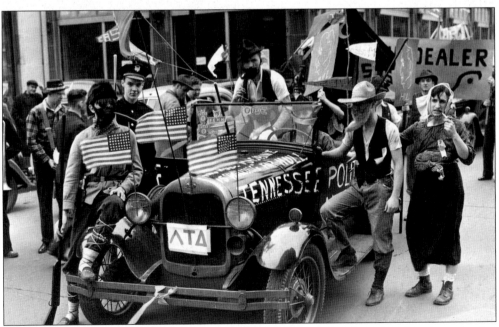

On April 19, 1940, at the Friday evening session of Fenn's second mock political nominating convention, the delegates nominated Cordell Hull for President and Senator Burton Wheeler for Vice President of the United States. Earlier in the day, the Lambda Tau Delta Fraternity, representing Tennessee, marched in the convention parade.

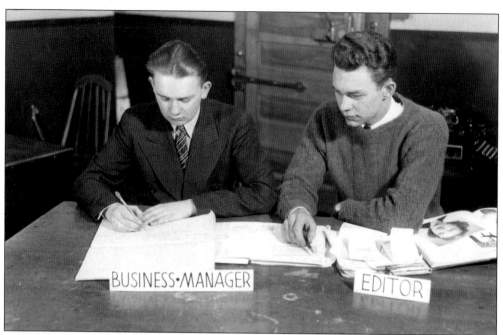

Alan Boers (B.B.A., 1947) was the business manager and Louis Polzer (B.B.A., 1941) was editor of *The Fanfare* in 1940. Originally called *The Envoy*, Fenn's yearbook changed its name to *The Fanfare* in 1932 and continued as a campus student organization until 1973.

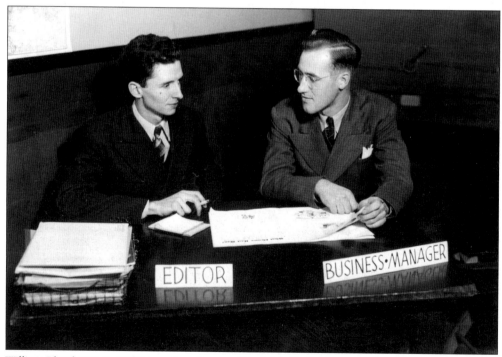

William Bland (B.S.E., 1940) was the editor and Rudolph Krall (B.B.A., 1941) the business manager for *The Topper*, Fenn's monthly student literary magazine. In 1940 the Fenn Student Government subsidized the magazine for the first time so that all students could receive a free copy.

In addition to the Flag Rush, a competition between freshmen and sophomores, there was the Bag Rush, another customized amalgamation of several sports, seen in this 1940 photograph.

Prior to America's entry into World War II, Fenn offered ground school courses to students electing an option offered by the Civil Aeronautics Authority. These classes, like this fall 1940 class, led the way to more vigorous defense training programs at the school. (Photograph by John Nash.)

Members of the "F" Club form a cheering section during a varsity sports competition. The club was formed to encourage student participation in intercollegiate athletics, stimulate interest in the athletic program among the student body, aid the school in the recruitment of athletes, and bring about a greater appreciation of the varsity "F" letter.

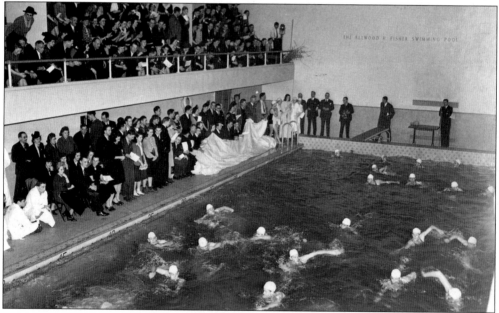

Demonstrations of swimming, diving, and surfboards were part of the dedication ceremony held February 19, 1941 for The Ellwood H. Fisher Swimming Pool on the fifth floor of Fenn Tower in honor of the head of Fisher Brothers Food Company and first chairman of Fenn College's Board of Trustees. Following the program, the Fenn varsity swim team faced Slippery Rock College in the inaugural meet.

This image depicts George Fay's (seated right) 1941 spring semester evening school Purchasing Techniques class in Fenn Tower 214. (Courtesy Gordon Greitzer.)

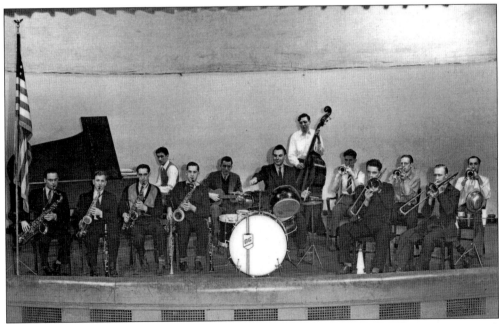

The Fenn Knights Dance Band is pictured performing in April 1941, including: John Arendt (B.S.M.E., 1944), Isadore Sheer, John Simiele (B.M.E., 1949), and Robert Meinke on saxophones; Robert Ailes (B.B.A., 1948), John Toaks, and Robert Harkelrode on trumpets; Robert Woods and Edward Byers (B.B.A., 1948) on trombones; Dean Gunther on drums; Duane Willis on piano; Paul Brunst (B.B.A., 1947) on guitar; and Roger Reed (B.S.Ch.E., 1947) on bass.

The Meriam Hydraulics Laboratory in the basement of Fenn Tower was established by Joseph Meriam, president of the Meriam Instrument Co., then the world's largest manufacturer of manometers used to measure pressures. Here Mr. Meriam tours the lab with Structural Engineering Professor Clifford Williams (1937–1943, B.S.C.E., 1937), *c.* 1941.

Freshmen co-eds stand on East 24th Street ready to depart by bus for the Fenn Freshman Camp at Centerville Mills, September 1941. A Fenn tradition, freshmen each year would spend a weekend at the YMCA's Centerville Mills Camp in Geauga County as a get-acquainted session prior to the start of the fall term. (Photograph by James Meli.)

Three

TIME OF ADJUSTMENTS 1942–1951

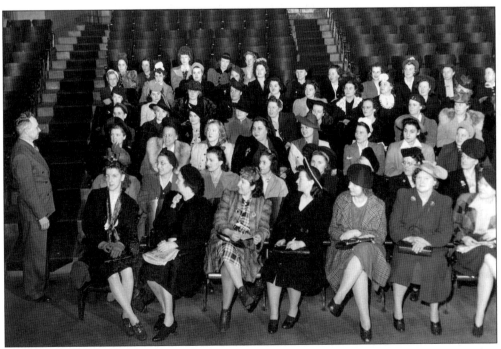

Chemical and Metallurgical Engineering Professor Gerald Greene (1934–1939) meets with a group of women interested in enrollment prior to the opening of the war industry course, April 1942. For its size Fenn was one of the largest providers of war emergency education in the federal government's Engineering, Science, Management, and War Training Program.

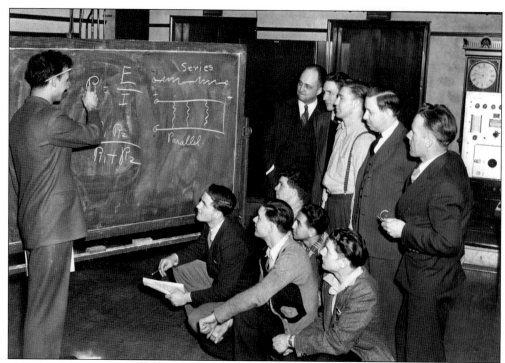

Marion Toler, Arts and Sciences dean from 1940 to 1955, stands near the chalkboard, observing a training class for the U.S. Signal Corp in the basement of Fenn Tower, April 1942. (Photograph by Clayton Knipper.)

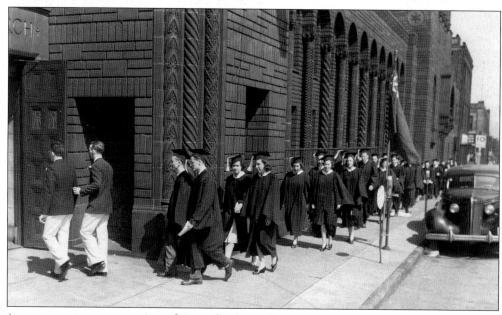

A commencement procession of Fenn faculty and students enter the Euclid Avenue Baptist Church at Euclid Avenue and East 18th Street, May 17, 1942. The commencement address, "The College and the Community," was delivered by Dr. Howard McClusky from the University of Michigan, and almost 100 graduates received their diplomas.

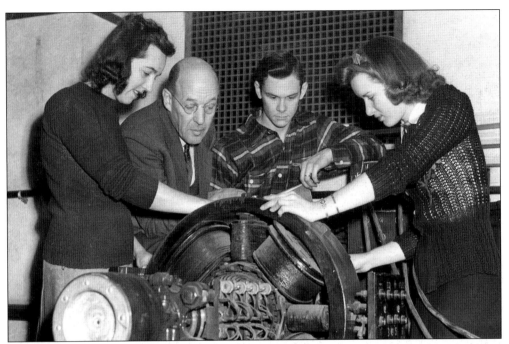

During World War II the federal government called on colleges and universities for accelerated instruction in various types of defense activities. Here Electrical Engineering Professor Marion Cooper (1937–1963) instructs U.S. Signal Corps class members Mary Mozina, Herbert Blessman, and Marjorie Lunsford, 1943. (Photograph by Clayton Knipper.)

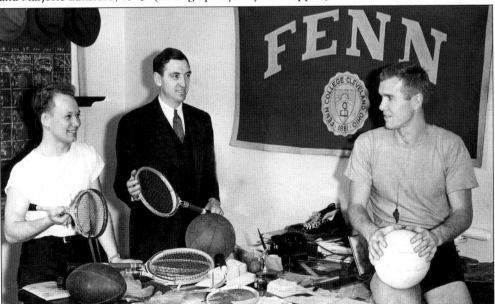

The Fenn College physical education instructors in 1943 included Peter Zoellner, Athletic Director Homer Woodling (1929–1967), and Varsity Swimming and Track Coach Raymond Ray (1936–1950). The 1881 date on the Fenn College banner would later be changed to 1923 to reflect the year that the Cleveland YMCA's college level education program started.

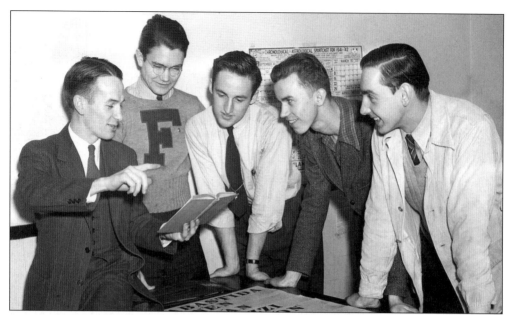

Coach Bruce Brickley tutors basketball players James Porcello (B.S.E.E., 1946; B.E.E., 1949), Edward Moyer, Richard Milota (B.Ch.E., 1943), and George Gafinski in Spanish. In addition to his duties as assistant director of admissions and teacher of physical education from 1941 to 1951, Mr. Brickley also served as the varsity basketball coach during the 1941–1942 season. (Photograph by John Nash.)

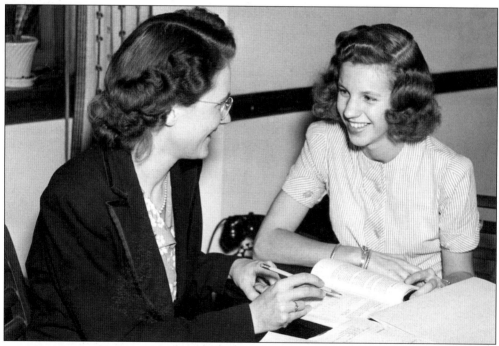

In addition to teaching English at Fenn and CSU, Margaret Knowles (1939–1946, 1949–1968) served as Fenn's first dean of women. She was with the college from Here the dean is in her office in 1943 talking with Fenn co-ed Ruth Blumenshein. (Photograph by Walter Kneal.)

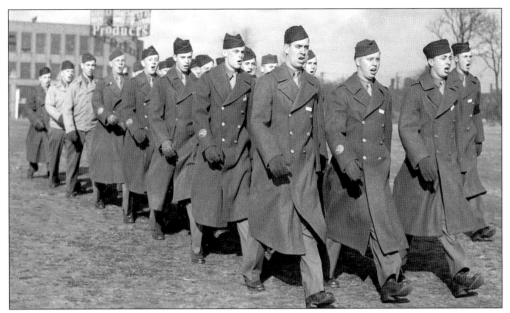

Faced with smaller enrollments due to the war effort, Fenn College opened its facilities to provide classes and training for the United States Army's 53rd Training Detachment. Here members of the detachment practice close-order marching on the open field at Chester Avenue and East 30th Street. Thompson Products can be seen in the background.

Cadets Phillip Bloom, John Blythe, and Herbert Beever of the U.S. Army's 53rd Training Detachment appreciatively crowd around Alice "Mom" Lewis, Fenn's cafeteria manager and supervisor of meals for the 53rd Detachment, March 1943. (Photograph by James Meli.)

During World War II Fenn College instituted an accelerated program to train engineers. Here Professor of Mechanics and Materials Samuel Ward works with a group of female college graduates on engineering fundamentals, 1943.

A major social event for the Lambda Sigma Chi sorority during the 1943–1944 school year was its sponsorship of the Serviceman's Ball, held October 16 on the third floor of Fenn Tower.

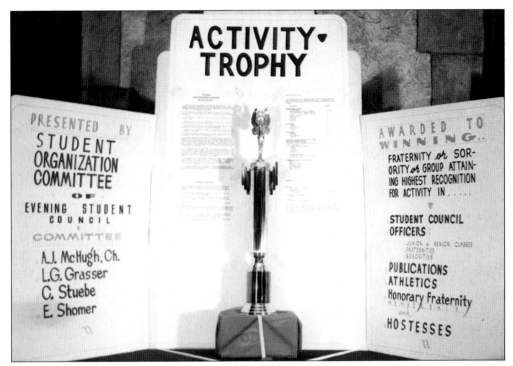

The Activity Trophy was awarded annually to the sorority, fraternity, or recognized group achieving the highest recognition for involvement in all aspects of campus life during each academic year. This photograph was taken in 1943.

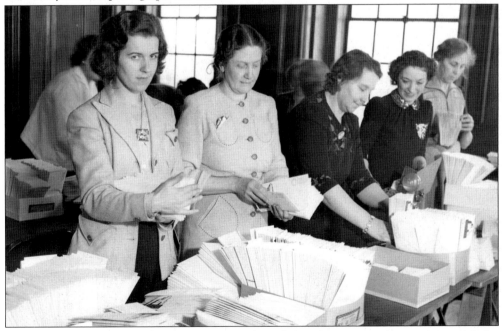

Members of the Association of Fenn College Women help to prepare promotional materials for the Admissions Office in January 1944. Pictured here are Mary Kopas, Sylvia Thomas, Julia Brooks, Victoria Rimboi, and Eileen Jordan.

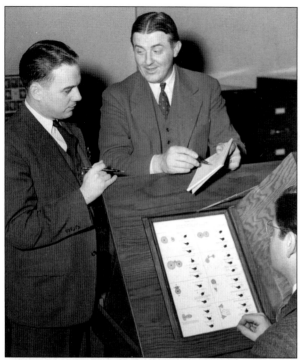

Walter Sites (1943–1950) and Joseph Kopas (1931–1949, B.E.E., 1931) of Fenn's Personnel Guidance Department watch as Daniel Lonaz takes an aptitude test on one of his test machines. Dr. Kopas was an innovator in the design of both aptitude tests and machines that could score those tests quickly and accurately. This image dates to April 1944.

The Fenn College Veterans' Association was believed to be Cleveland's first organized group of World War II veterans. Pictured standing in this August 1944 photograph are Charles Sharp (B.B.A., 1941), Louis Humphrey, Stanley Robertson, George Williams, Harold Reed (B.B.A., 1947), Robert Chatterson (B.A., 1947), Raymond Brendle, Robert Crossman, and Armand Petti. Seated are Sanford Shilikoff, George Assad, William Lebet, Andrew Rozum (B.B.A., 1947), Philip Andes (B.B.A., 1947), and Daniel Lomaz (B.E.E., 1947).

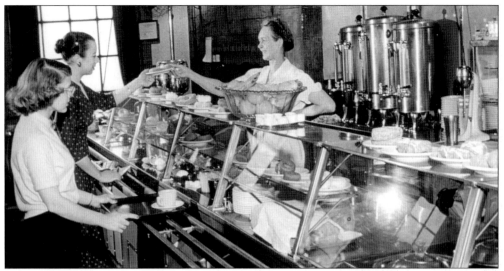

The Fenn Tower cafeteria was located on the third floor. In 1961 after the Stilwell Hall cafeteria opened the Fenn Tower cafeteria was scaled back to a snack bar operation. This photograph dates to *c*. 1944.

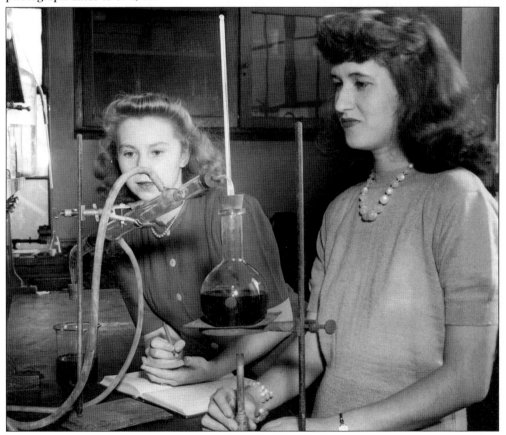

Science majors Dorothy Steen (B.S., 1945) and Dorothy Sochinsky (B.S., 1945) are pictured at work on an experiment in the Fenn Building chemistry laboratory, *c*. 1944.

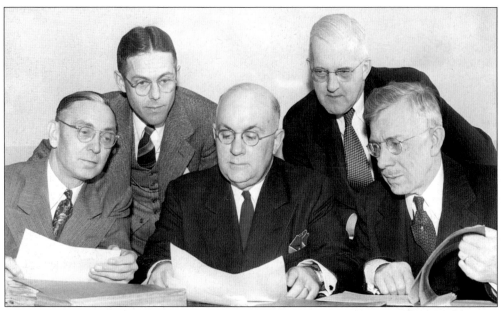

No other single person was more responsible for the early growth and development of Fenn College than its first president, Dr. Cecil Vincent Thomas (1923–1947). In this 1945 photograph Dr. Thomas is flanked by Dean of Fenn College Dr. Joseph Nichols (1920–1951); School of Arts and Sciences Dean Major Jenks; School of Business Administration Dean Paul Anders; and School of Engineering Dean Max Robinson.

The S.S. *Fenn Victory* VC2-S-AP2, named in honor of Fenn College, was one of 534 Victory ships built during World War II for the U.S. Maritime Commission. Launched May 19, 1945, the S.S. *Fenn Victory* was 455 feet long and 62 feet wide. It had a cross-compound steam turbine with double reduction gears that developed 6,000 (AP2 type) or 8,500 (AP3s type) horsepower.

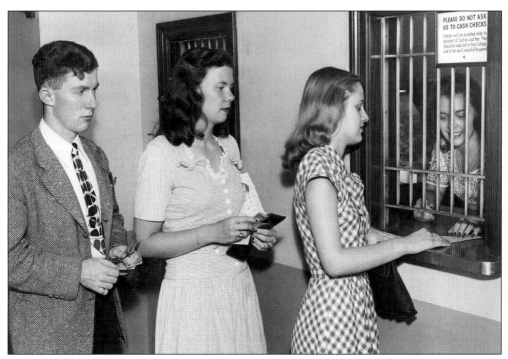

Fenn freshmen Jean Kirk, Carol Dunbar, and Tom Haywood line up to pay their tuition for the 1945 fall term at the cashier's cage in Fenn Tower. The 1945 freshman class of 140 was the largest since 1941 with a breakdown of two men for each woman.

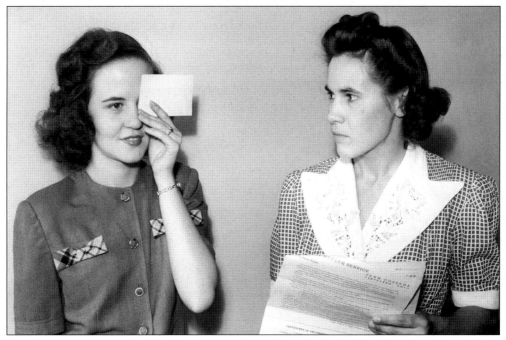

Health examinations were just one of a number of Fenn College entrance requirements. Here Director of Women's Physical Education Jane Pease (1944–1982) administers an eye test to freshman Margaret Preston in September 1945.

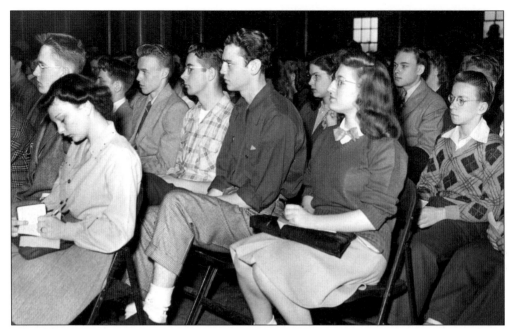

On March 23, 1946, the Sociology Department held its annual High School Conference in Panel Hall. High schools including Brecksville, Brush, Cuyahoga Heights, Elyria, Euclid, Central, Glenville, John Marshall, Lincoln, Solon, and South High met to consider the topic, "How to live with others—the question of relationship between races."

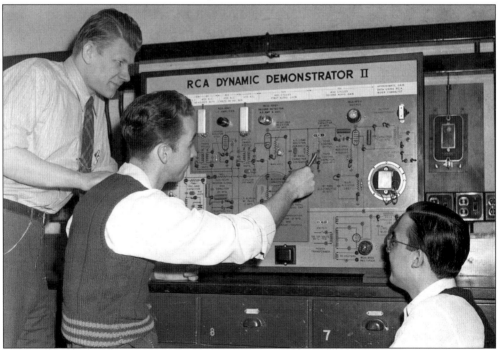

Kenneth Milbrodt (B.S.E.E., 1950), John Matthews (B.E.E., 1948), and William Peschel (B.E.E., 1947) study a control board for an RCA table model radio in the Electrical Engineering Laboratory, 1946. (Photograph by Lou Moore.)

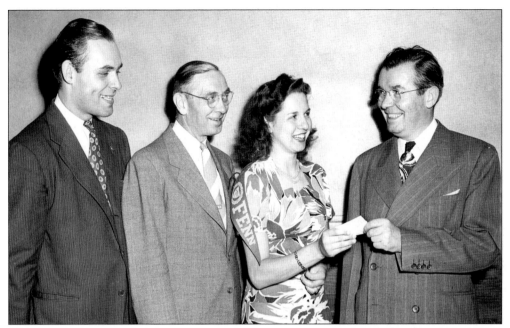

In this July 1946 photograph Betty Dolinar (B.S., 1946) presents the first two tickets to the Fenn College Carnival and Street Dance to Cleveland Mayor Thomas Burke while Planning Committee Chairman George Foltz and Dean of the College Joseph Nichols look on. Proceeds from the event were used to establish a memorial scholarship fund to honor the 69 Fenn alumni and students killed in World War II.

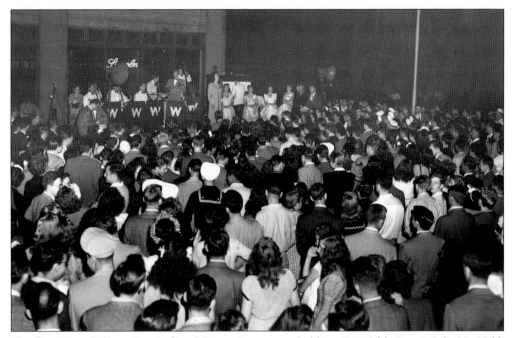

The first Fenn College Carnival and Street Dance was held on East 24th Street, July 20, 1946. Performing on stage are Tommy Dorsey Singing Contest contestants Julie Ann Bishop, Yolanda Casini, Jeanne Johnson, Bernadine Novak, and Patricia Bosley.

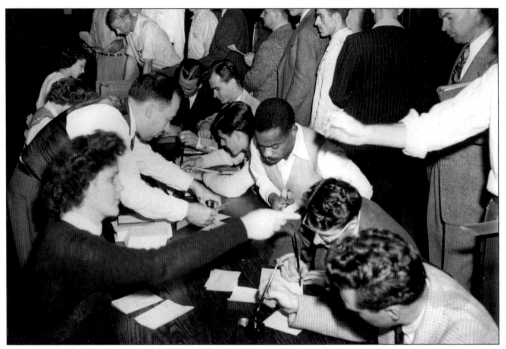

Like many other schools, Fenn saw a sharp increase in enrollment following World War II as returning U.S. veterans took advantage of provisions in the G.I. Bill. Here a crowd of mostly veterans await their chance to register for classes. Registrar William Patterson is on the left.

Once the vets had finished waiting to register for classes, they then had to wait in line to get into the college bookstore on the first floor of Fenn Tower.

On June 16, 1946, Associate Justice of the United States Supreme Court Harold Burton presented Fenn College a 39-volume set of the complete writings of George Washington. Justice Burton, a former mayor of Cleveland and United States senator, had also been a member of Fenn's Board of Trustees. In 1953 Fenn Trustee Clayton Hale presented the school a gift of an oil painting of Justice Burton by Alfred Jonniaux.

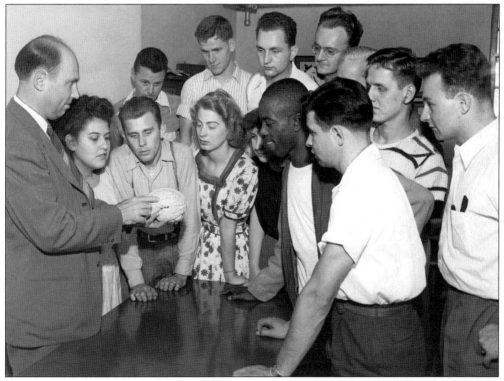

The abnormal psychology class visits the Cleveland State Hospital on a field trip, September 1946.

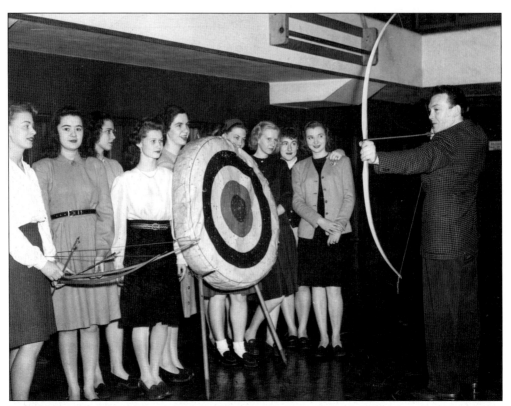

In 1946 band leader Freddie Slack and his boogie woogie orchestra played for Beta Beta Alpha's Harvest Prom. Here the amiable Slack, composer of "Cow Cow Boogie" and other hits, took time out from his engagement at the Palace Theater to practice archery with some Fenn co-eds.

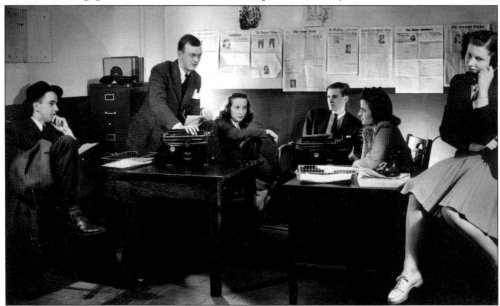

Members of the 1946–1947 staff of *The Cauldron*, Fenn's student newspaper, are pictured here. Standing is the paper's editor, Victor Pignolet (B.S.E., 1950). To his right is Dagmar Kuntz.

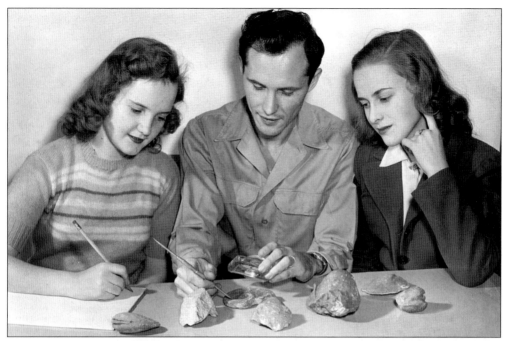

Fenn Fossil Club members Margaret Ann Quinn (B.Ch.E., 1950), James Schaefer (B.Ch.E., 1949), and Dorothy Carter examine fossil specimens during a club meeting in 1947. (Photograph by Fred Bottomer.)

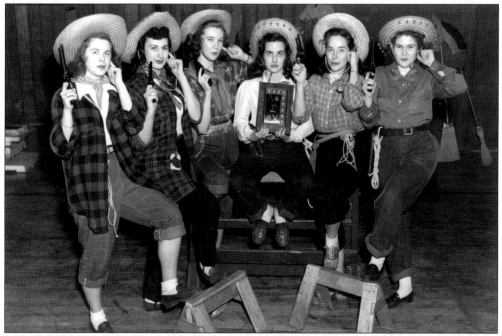

Lambda Sigma Chi sorority pledges Laverne Davis, Claire Gaeto (B.A., 1950), Agnes Murphy, Ardeth Shatz, Edythe Barlow, and Florence Pospishil (B.B.A., 1950) had to raise their six-shooters and fire a salute to the sorority plaque everyday for the amusement of other students as a preliminary to their informal initiation into the sorority, March 1947.

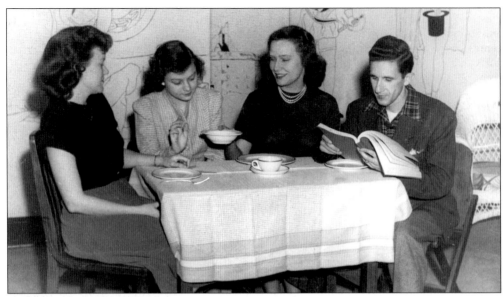

Originally, theatrical productions by the Fenn Players were staged entirely by the students. Directing duties were later assumed by the drama faculty. The 1947 spring production was the premiere of the comedy *Cynthia* by Drama Professor George Srail (1946–1976). The cast included Terry Stone, Margaret Silver (B.B.A., 1949), Joseph Black, Robert Drennan (B.A., 1953), Rita Martens (B.B.A., 1952), Lois Overson (B.S., 1950), James Elder (B.B.A., 1950), and Delores Albanese (B.A., 1948).

Neil Gowe, editor of *The Fanfare*, Fenn College's yearbook, is pictured with Dr. Clyde Crobaugh, to whom the 1947 edition was dedicated. Dr. Crobaugh, who served two stints on the faculty, as professor of marketing from 1942 to 1948 and professor of economics from 1957 to 1962, spent years compiling a list of almost 1,300 invectives and curse words, which he published in the book, *Abusive Words*.

This 1947 photograph illustrates the dichotomy of Fenn's student body during the immediate post-World War II years. On the left are Gerald Clark, representative of the older World War II veteran and family man, and his family. On the right are freshmen Elliot Abel and Jeanne Klett, recent high school graduates.

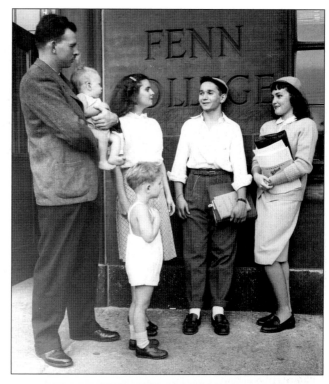

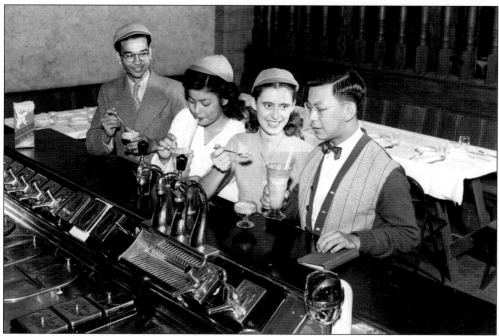

For a small urban commuter college Fenn attracted a significant number of international students. Sharing chocolate sodas and double-dip sundaes in 1947 are Tin Maung Maung Galay from Burma, Mildred Nakama from Hawaii, Nolene Kakouros from Greece, and Eugene Chang from Peru.

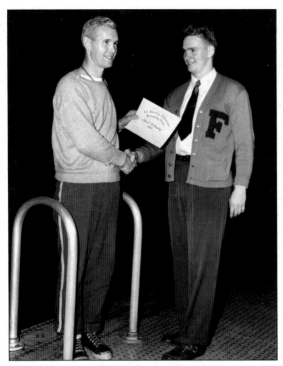

In a November 1947 ceremony at the Ellwood H. Fisher Swimming Pool on the fifth floor of Fenn Tower, Fenn Varsity Swimming Coach Raymond Ray presents the All American Collegiate Swimming Team certificate to Robert Busbey (B.S., 1950). Fenn's first All American, Busbey served as Fenn's swimming coach and later as CSU's athletic director (1951–1990). The CSU Natatorium is named in his honor.

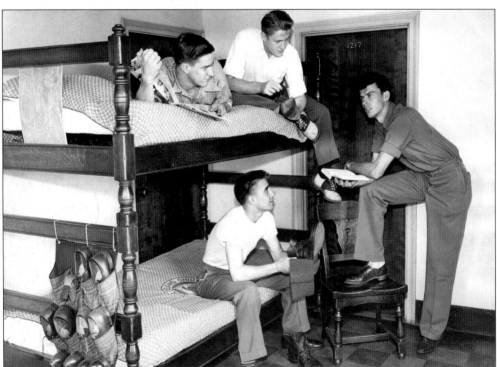

Dormitories at Fenn were located on the upper floors of Fenn Tower and were restricted to male students. Here U.S. veterans Ivor Evans and Lou Humphrey are on the top bunk holding a "bull-session" with Philip Andes (B.B.A., 1947) and Richard Brady (B.B.A., 1947), *c.* 1947.

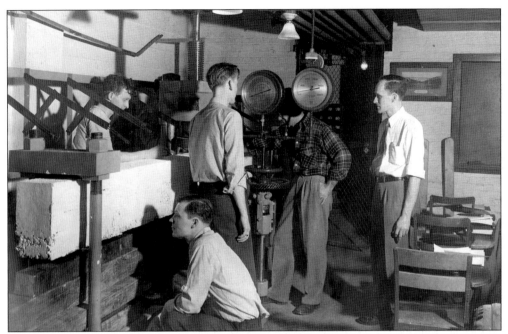

Ernest Harris (1942–1967, B.C.E., 1939) taught structural and civil engineering for 45 years at both Fenn College and CSU, rising to professor of civil engineering and department chair. Here Professor Harris watches over students in the Fenn Building Civil Engineering Laboratory, c. 1947.

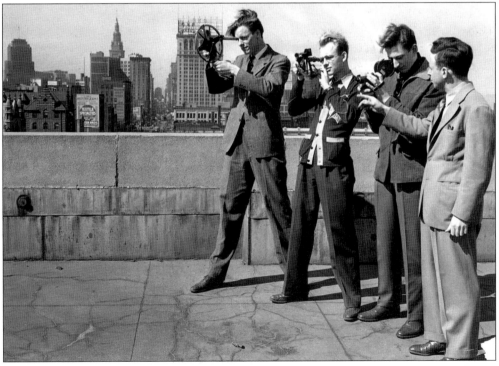

Engineering students get experience using a ringdial, an octant, and a sextant on the roof of Fenn Tower, c. 1947.

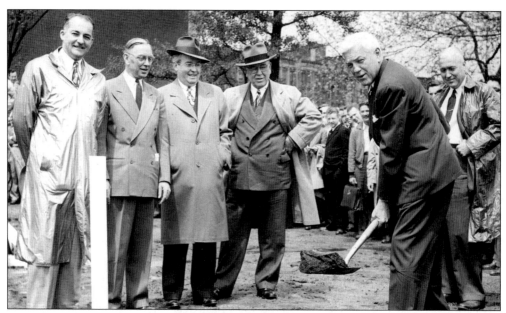

Ohio Governor Thomas Herbert turns the few first shovels of dirt at the groundbreaking ceremony for Fenn's new Mechanical Engineering Building on Euclid Avenue, May 17, 1947. Standing to his right are Fenn Trustee Richard Huxtable, Fenn Acting President Joseph Nichols, Cleveland Mayor Thomas Burke, and Chairman of the Trustees Charles Stilwell. It was the second and the last building constructed for the college.

Virginia Savodnik Lindquist (B.Ch.E., 1950) and Marguerite Jost were recognized for making the 1948 Spring Term Dean's List.

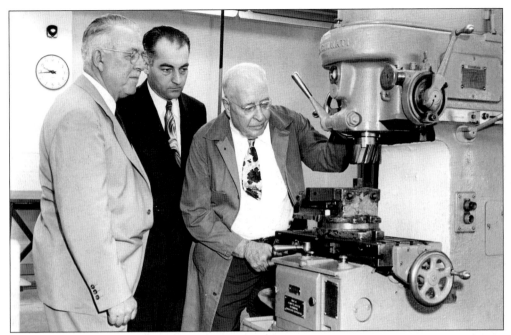

Fenn College Trustees Charles Stilwell and Richard Huxtable look on as Claude Foster inspects the machinery in the Foster Building Production Laboratory. The Claude Foster Engineering Building was dedicated on September 14, 1948. Inside the main entrance hung a portrait of Mr. Foster along with a quotation that summed up his philosophy: "You cannot tell anyone else how to make things unless you have made them with your own hands."

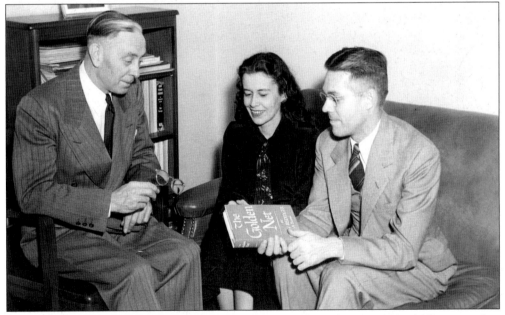

After graduating in 1936 with her B.A. in English Dr. Ruby Redinger (1939–1951) returned to teach in the English and Philosophy Departments. Here she is with Dean of Fenn College Dr. Joseph Nichols and Dean of the College of Arts and Sciences Dr. Major Jenks in 1948 at the time of publication of her first novel, *The Golden Net*.

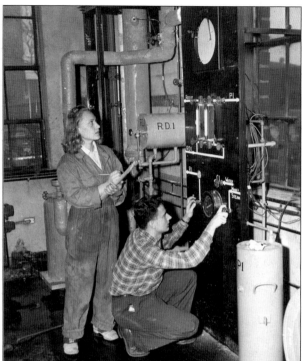

Rosemary Hanula and Stanley Lepkowski (B.Ch.E., 1949) check the distillation tower in the Chemical Engineering Laboratory in the Fenn Building, 1948. (Photograph by Herman Seid.)

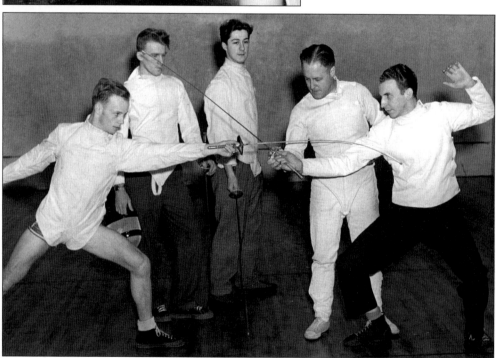

The Fencing Club was organized in 1948 to teach fencing and ultimately gain varsity team status. Here Coach Madison Dods (B.S.M.E., 1934) gives instruction to club members Albert Reeves, William Semenik (B.E.E., 1950), Sal Anguilano, and Walter Schaffer (B.E.E., 1950). The club became inactive in 1950 when fencing was reactivated as a varsity sport.

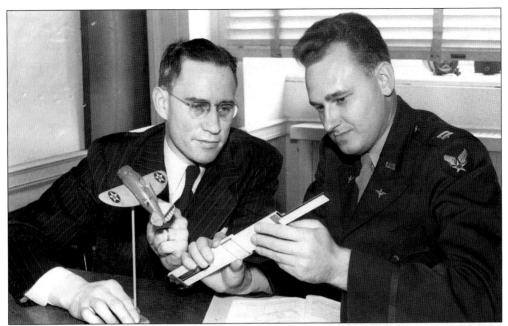

Physics Professor Willard Poppy (1934–1950) welcomes U.S. Army Captain Edwin Istvan (B.S.E., 1946), who has returned from studies at the University of California for Homecoming 1948. In 1937 Dr. Poppy helped Fenn engineering student Walter Schaefer design and install a 211-foot Foucault pendulum down a Fenn Tower air shaft.

On November 11, 1948, Fenn held a special dinner honoring the silver anniversary of the Cooperative Education Program at the college. Shown here are Fenn's special guest speaker, automotive pioneer Dr. Charles Kettering, Fenn College President Dr. Edward Hodnett (1948–1951), Case Institute of Technology President T. Keith Glennan, and George Codrington, head of General Motors' Cleveland Diesel Division.

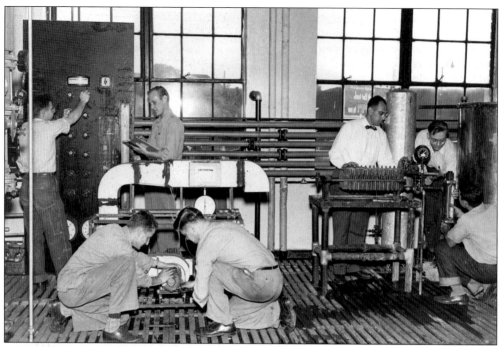

Chemical engineering students work on their experiments in the Fenn Building Chemical Engineering Laboratory under the supervision of Dr. Aaron Teller (1947–1956), c. 1948.

Vance Chamberlin taught Marketing either part-time or full-time at the Cleveland YMCA schools and Fenn College from 1918 until 1965. Here Professor Chamberlin explains the elements of a marketing campaign to an evening division marketing class, c. 1949.

The "Woody Brick" trophy, named for Fenn College Athletic Director Homer Woodling, symbolized the basketball rivalry between Fenn and Hiram College. Varsity Basketball Coach George Rung (1949–1958) and Fenn team members Harlan Martens (B.B.A., 1956) and Danford Avis (B.B.A., 1951) pose with Woody after its latest return to Fenn.

The Harvest Prom was traditionally Fenn's first major dance of the school year where each year a queen was chosen. After Fenn started holding annual homecoming dances the Harvest Prom became the event where homecoming queen candidates were officially introduced. In 1949 the candidates for Harvest Prom Queen were Martha Cook, Frances Block (B.B.A., 1963), Ruth Timbers, Lois MacDowell, and Nancy Osborne.

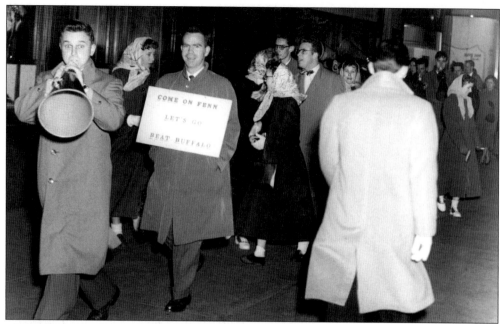

On opening night of the Fenn College Varsity Basketball Team's 1949–1950 season, Richard McCord (B.S.E., 1950) and Robert Stevens (B.B.A., 1950) lead a pep parade down Euclid Avenue. The final score was Fenn 65 to Buffalo State's 56, and the basketball team went on to post a 10–8 record for the year.

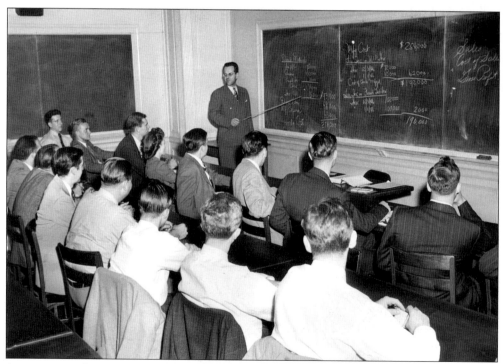

Accounting Professor John Froebe (1946–1965) explains a problem on the chalkboard to his Cost Accounting class in Fenn Tower, *c.* 1949.

Andrew Slivka (1948–1953), a mechanical engineering instructor, watches John McClurg (B.Met.E., 1951) using the lathe in the Foster Hall Mechanical Production Lab, 1950.

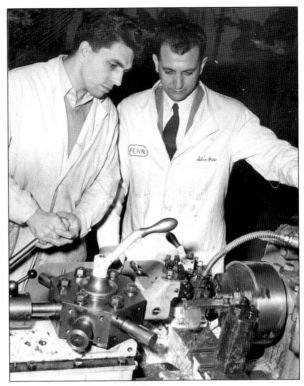

Raymond Richards (B.S.E., 1952) and William Kosko (B.M.E., 1956) examine a tool demonstration kit in the Mechanical Production Laboratory in Foster Hall, 1950.

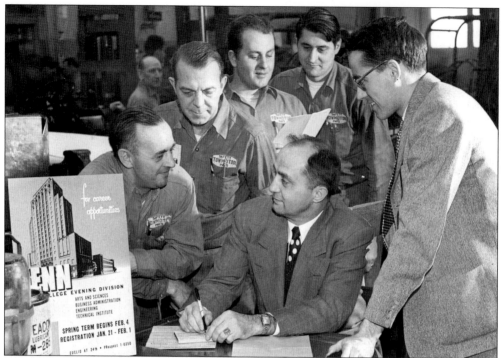

Director of the Fenn College Technical Institute Nicholas Rimboi (1937–1976, B.S.E.E., 1934) registers employees at the Tow Motor Co. for spring term classes at the institute, 1950.

Once part of Cleveland's "Millionaires' Row," the James Jared Tracey home at 3635 Euclid Avenue was renamed Bliss Hall by Fenn and was used as a women's dormitory from 1943–1951. It was named in honor of Loretta Bliss, who contributed money for furnishings. Here is a view of the first floor living area, c. 1950. The house was torn down in 1951 to make way for a parking lot.

In 1951 Fenn expanded its corporation and initiated a program whereby each week an average of two corporation members would conduct workshops on campus to help classes keep up with advances in business and industry. Here Jay Iglauer, vice president of Halle Brothers Department Store, conducts a workshop for the marketing class, the first under the new program.

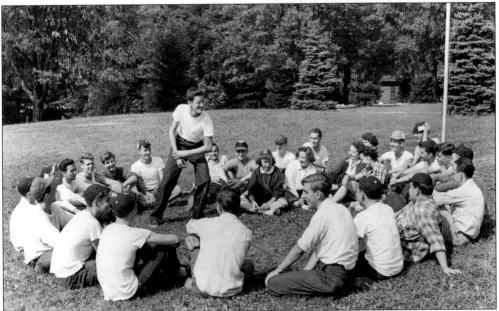

William Qualich, a member of the Fenn Players, entertains a group of Fenn freshmen at the YMCA's Centerville Mills campground in September 1951. Fenn's Freshman Camp offered a variety of programs and activities that allowed the new students to become acquainted in a relaxed and informal setting.

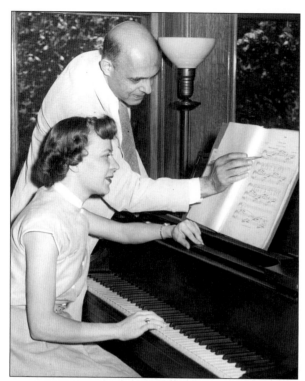

Fenn started its program in music in conjunction with the Cleveland Institute of Music in the fall of 1952. Here Mary Bukartyk (B.B.A., 1953), the first registrant for the new program, auditions for CIM Director Beryl Rubenstein. (Photograph by Walter Kneal.)

The Fenn Players' 1952 fall production, held November 14 and 15 at the Central YMCA Auditorium, was the world premiere of *Penalty Deferred* by Fenn Professor George Srail. It was based on an actual experience in Cleveland during the war years when Srail worked in an airplane parts manufacturing plant. The cast included Daniel Pournarous, Thomas Harmon (B.B.A., 1954), John Revelt, Andy Boschetto (B.B.A., 1953), Shirley Troyan (B.A., 1953), and Claire Moulk.

Four

EARNEST ENDEAVORS
1952–1965

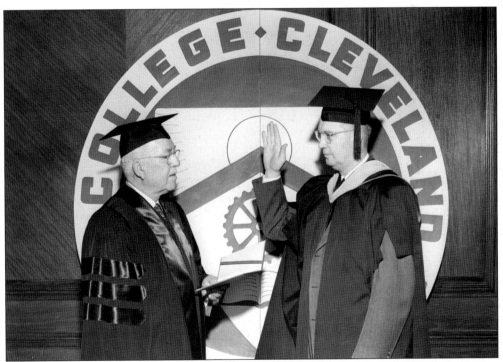

Fenn College Board of Trustees Chairman Charles Stilwell swears in Dr. G. Brooks Earnest as Fenn College's third president on May 9, 1953. Inauguration Day events included a buffet luncheon in the Fenn Tower Oak Room, an academic procession, and the inauguration at the Cleveland Music Hall, the president's reception back at the college, and an inaugural dinner at the University Club.

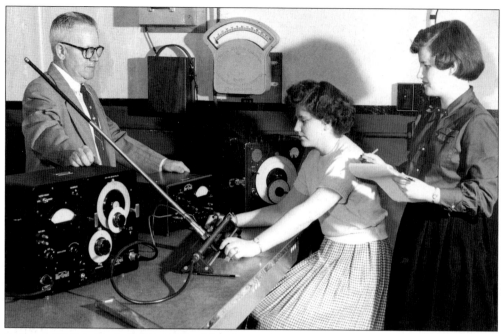

Professor William Davis (1928–1956) of the Electrical Engineering Department instructs Margaret Steven (B.E.E., B.E.S., 1958) and Rita Martin on the use of electric equipment in the Electrical Engineering Laboratory, 1953. (Photograph by Bernie Noble.)

During 1952 and 1953 renovations were made to the eighth and ninth floors of Fenn Tower. This view looks north from Euclid towards Chester Avenue and shows East 24th Street when it was a through street. On the east side behind Fenn Tower the Quonset Huts, Sadd's Restaurant, and the White Apartment Building can be seen.

A former instructor in the U.S. Army Air Corps, Selma Montasana (1946–1962) first came to Fenn College as an instructor in physics. In 1952 she was appointed dean of women. Here she is with Fenn co-eds Mary Lou Franks and Renee Katz in 1953.

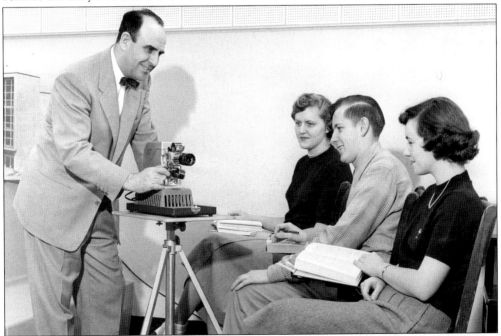

Shortly after Fenn upgraded Nash Junior College to a four-year bachelor's degree program, the School of Arts and Sciences started its secondary education teachers-training program. Here Dr. John Matthews (1948–1957) demonstrates the use of a film-strip projector before members of his class, c. 1953.

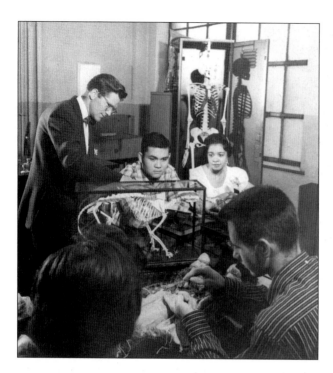

Dr. Ronald Clise (1951–1984) of the Biology Department assists students on a lab exercise in the Biology Laboratory in the Fenn Building, *c.* 1953.

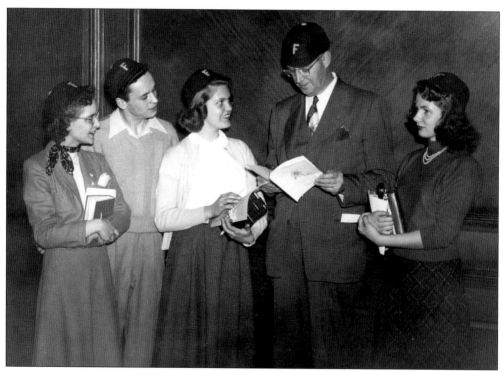

Fenn College President G. Brooks Earnest wears a Fenn College Freshman beanie while talking to a group of Freshman in Panel Hall of Fenn Tower, *c.* 1953.

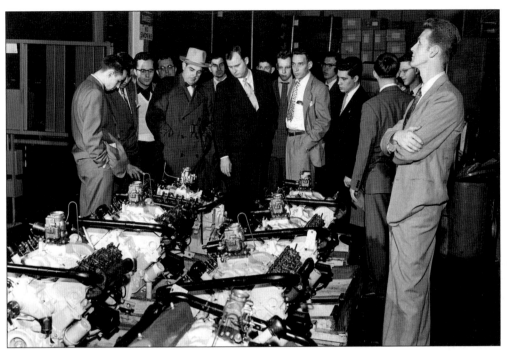

Led by Mechanical Engineering Professor Chester Kishel (1948–1981), senior engineering majors examine recently built automobile engines during a field trip to the Ford Motor Company's River Rouge Plant in Dearborn, Michigan, on February 17, 1954.

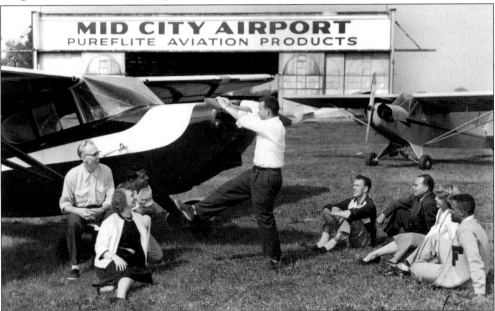

The Fenn Flying Club, the first of its type in the Cleveland area, was established in 1954 to encourage and promote the education and advancement of flying. This photograph from September shows the club's first president, James Bede, with his hands on the propeller of the club's Aeronca 058B. The club's advisor, Civil Engineering Professor John Arendt (1947–1957), is seated on the right.

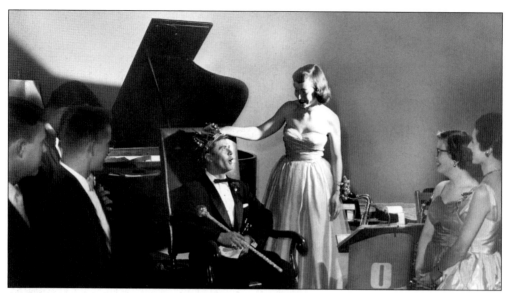

Wayne Gest is crowned "Kampus King" at the second annual Coronation Ball, co-sponsored by Beta Sigma Omicron sorority and Kappa Delta Phi fraternity, at the Wade Park Manor, November 24, 1954. Music was provided by Omar Blackman and his orchestra. Having sponsored the Thanksgiving Prom for many years the two groups changed the dance's format to hold a "homecoming queen" style of competition for men.

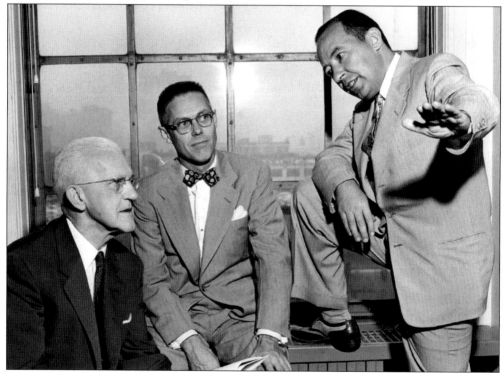

Posing together in the second-floor hallway of Fenn Tower, *c.* 1956, are Business Administration Dean Paul Anders (1929–1964), School of Arts and Sciences Dean Major B. Jenks, and School of Engineering Dean William Patterson.

Fenn was the second college in Ohio to adopt the co-operative education program. Students enrolled in the Day Division generally alternated between the classroom and practical work experience in their major field. Max Robinson (1933–1959), pictured *c*. 1955, spent most of his career at Fenn directing the Co-op Program.

Business Professors Maria Center Faust (1942–1965) and Pauline Bloomquist (1941–1972) pose with English Professor Sarah Ruth Watson (1940–1970) outside of Fenn Tower. Professors Faust and Bloomquist taught in the Secretarial Studies Department while Dr. Watson, the daughter of bridge architect Wilbur Watson, also taught classes in the Civil Engineering Department. This image dates to *c*. 1955.

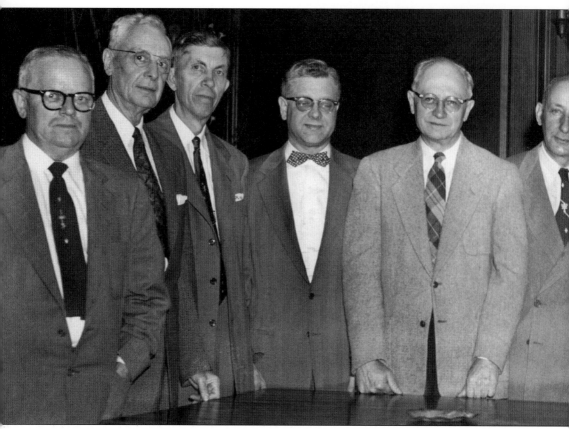

Pictured here are Fenn College's senior faculty from the year 1956: William Davis, Electrical Engineering; G. Hamlin Mouck, Accounting; Millard Jordan, Sociology; Donald Tuttle, English;

Following his graduation from Fenn, Frank Gallo (B.S.E., 1943) worked as an engineer for General Motors' Fisher-Cleveland Aircraft Division. In 1946 Frank returned to Fenn as a faculty member in the Engineering School, where he spent the next 38 years. Here Frank works with students Fred Hollman (B.M.E., 1961) and Ray Juchnowski out in the field on a surveying problem, c. 1956.

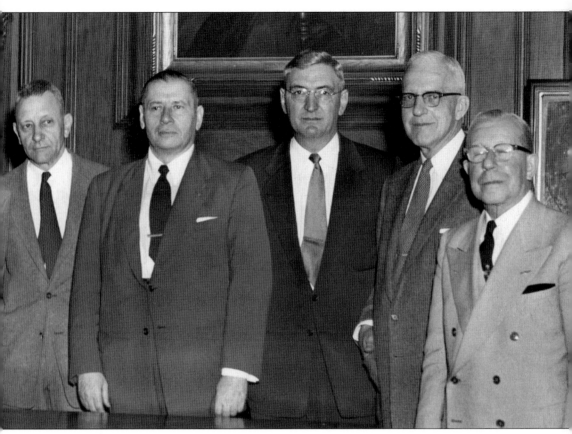

Lad Pasuit, Chemistry; Randolph Randall, English; Virgil Hales, Engineering Drawing; Homer Woodling, Athletics; Dean of Business Administration Paul Anders; and George Simon, Speech.

Professors Urban Von Rosen and Vance Chamberlin are pictured in the reference stacks of the College Library, c. 1956. In 35 years Accounting Professor Von Rosen (1922–1957) prepared more accountants for the CPA exam than any other Fenn instructor. He did so with such success that Fenn had a higher percentage of CPAs among its accounting graduates than any other Ohio college.

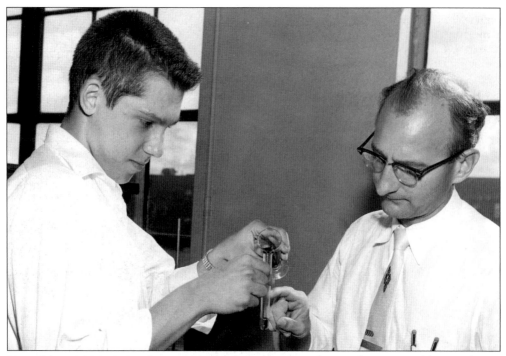

Louis Salzer (1951–1959), chemistry instructor, assists a student in the Fenn Building Analytical Chemistry Laboratory, c. 1955.

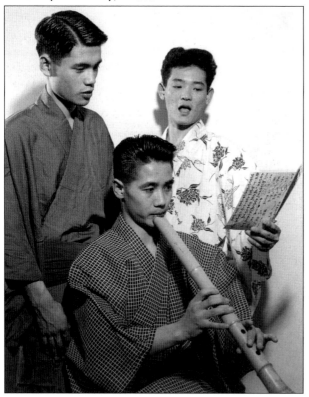

In April 1956 Fenn held a Folk Festival featuring Fenn's international students in the national songs and dances of Armenia, China, Croatia, Honduras, Hungary, Japan, Korea, Lithuania, and the Ukraine. Fenn freshmen Daisaku Harada (B.B.A., 1961) and Kit Tada (flute) and junior Kenzi Miyazawa practice their performance of native Japanese music.

Fenn College President G. Brooks Earnest and Lucius Wilson Jr. (B.B.A., 1965) look over Wilson's transcript. Lucius completed the seven-year evening division business degree program in only five years, the shortest time for any student in Fenn's history.

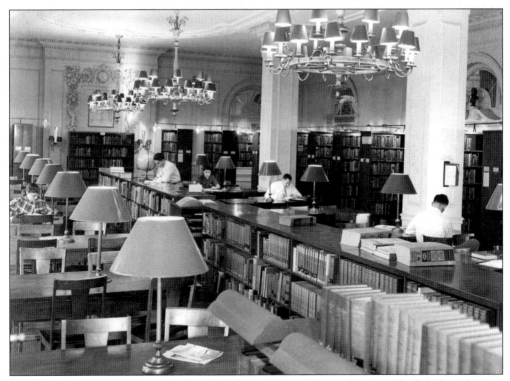

The Fenn College Library was on the third floor of Fenn Tower, the second of its three homes, 1938–1959.

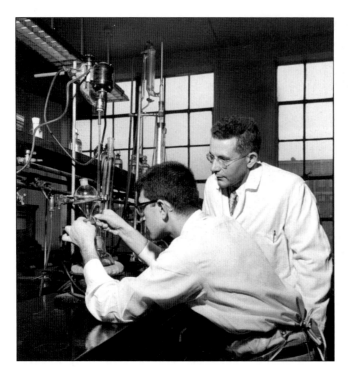

Chemistry Professor Dr. Charles Springer (1951–1959, B.Ch.E., 1948) observes as George Ajemian (B.S., 1957) works on a project in the Fenn Building's organic chemistry laboratory, *c.* 1956.

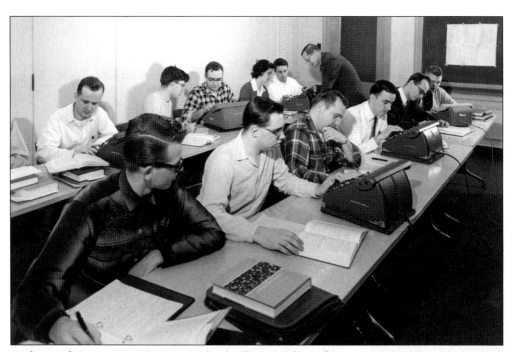

Professor of Economics and Statistics Lloyd Billings (1948–1960) wrote or co-authored economic studies on the impact of the St. Lawrence Seaway, radio listening habits of Clevelanders in 1950, and consumer acceptance of self-service pre-packaged meats. He is seen here assisting students doing classroom exercises in his spring 1957 Business Statistics class.

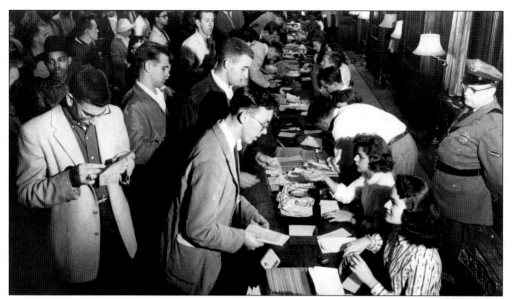

Today students can register electronically for college classes at home using their computers. For students in the 1950s registration often meant standing in long lines to get class cards all the while hoping that they would not get closed out of a needed class. Here evening students fill Panel Hall on the third floor of Fenn Tower waiting their turn to register for spring semester classes in 1957.

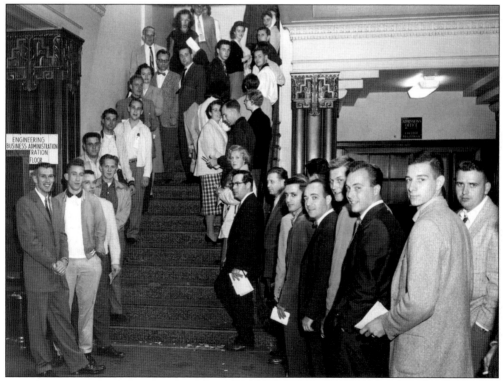

How long could the lines to register for classes get? Here the line for the 1957 spring term stretches out from Panel Hall on the third floor and down the stairs to the second floor of Fenn Tower.

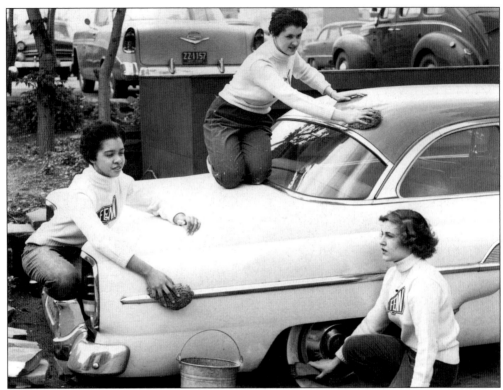

Cheerleaders Tillie Rossen and Ursula Schlamme (B.E.S., 1960) and Squad Captain Jean Scherz (B.A., 1959), in the center, are busy soaping and sponging cars during a two-day car wash benefit held at the college's parking lot in May 1957. The benefit was sponsored by the cheerleaders to earn funds for new uniforms.

Melodrama Night was a summer tradition for the Fenn Players that featured a combination of campy melodramatic productions and vaudeville routines. First staged in 1946 at the Orange Village recreation area in 1946, it later moved to Cain Park in Cleveland Heights. Behind the scenes, director George Srail does a last-minute check with the cast, including a group of Charleston dancers.

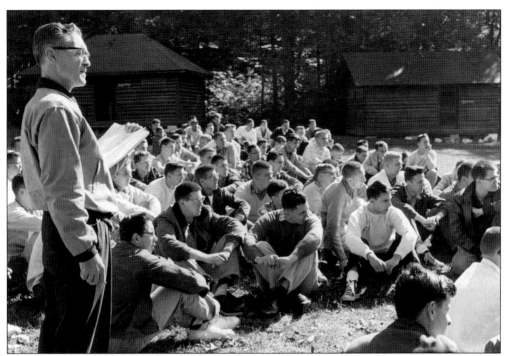

Director of Admissions Meriam Herrick (1938–1967) watches the program with a group of Fenn freshmen at the Freshman Camp at Centerville Mills, September 27–28, 1957.

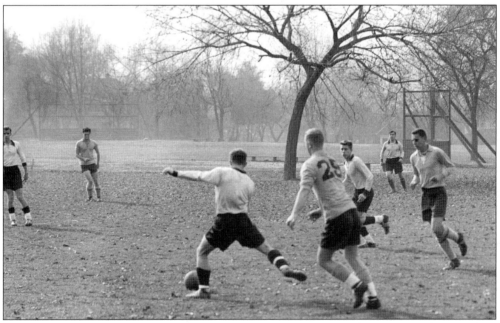

Soccer was Fenn's major fall varsity sport. The team practiced at East 40th Street and played their home games on several different fields throughout Cleveland. Here Coach Jack Marshall's Foxes advance the ball against Allegheny College on a November afternoon in 1957. Final score was Fenn College: 3, Allegheny College: 1.

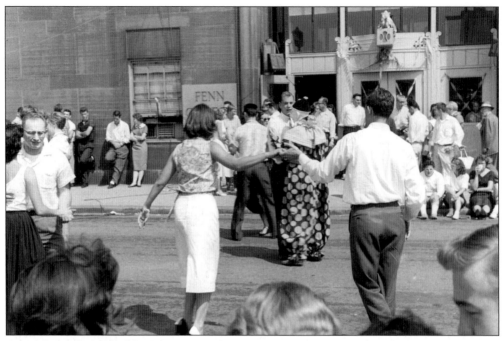

To celebrate the end of final exams and the school year, a Street Dance was held on East 24th Street in June of 1958.

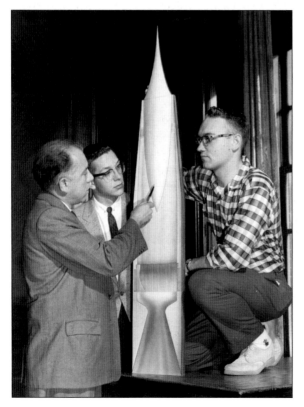

The launch of Sputnik in 1957 ignited a new intensity of interest in space travel. In 1958 Fenn students formed the first college chapter of the American Rocket Society in the Cleveland area. Here Mechanical Engineering Professor Albert Lord (1956–1960); the chapter's faculty advisor, Allan Smith (B.E.S., 1962); and John Fetters (B.E.E., 1968) examine a model of a nuclear powered ramjet rocket, November 1958. (Photograph by Frank Aleksandrowicz.)

Joanne Lavrick, Melanie Zentar, Patricia Ramsey, Bernice Pazada, and Janice Melda are busy preparing the December 1959 issue of *The Night Shift*. The first issue of the Evening Division's student newspaper appeared in March 1948. Staffed by students who worked during the day and took classes during the evenings, *The Night Shift* focused solely on the concerns and events happening in the Evening Division.

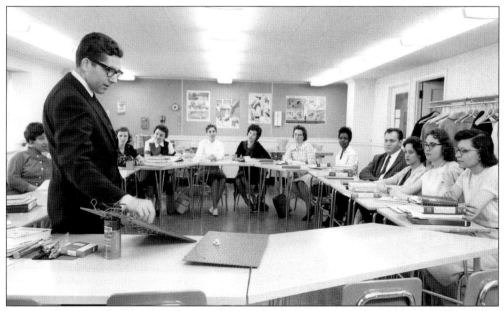

In 1953 Fenn College expanded its teacher education program to include certification in elementary education. Here Dr. Gordon Samson (1957–1985) performs a typical classroom demonstration using electricity to an evening education class in Fenn Tower, *c.* 1958.

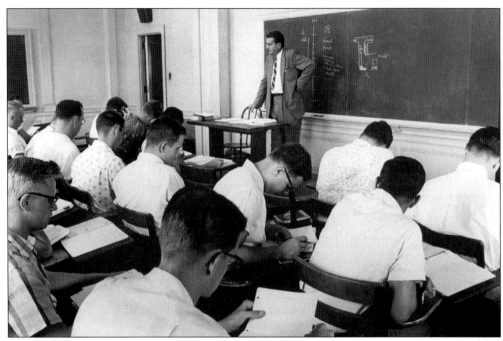

Management Professor John McNeill (1945–1969) makes a point to his introduction to industrial management class, *c.* 1958.

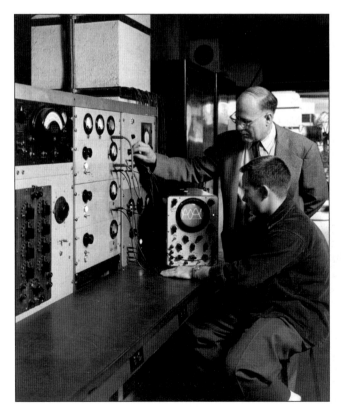

Dr. Robert Schlinder taught electrical engineering for 36 years, and 32 of those years were at Fenn College and CSU, from 1941 to 1973. Here Professor Schlinder assists an engineering student in the electrical engineering laboratory, *c.* 1958.

Although engineering students no longer got to go to the freshmen surveying camp in Hiram, Ohio, they still had numerous opportunities to hone their surveying skills in the field. Here Civil Engineering Professor Michael Phillips (1950–1965) works with a group of students on a field problem at the northeast corner of the campus near Chester Avenue, *c.* 1958.

Dr. William Cherubini taught British literature at Fenn and CSU for 33 years, from 1943 to 1976. Here he works with a freshman on phonetics, *c.* 1958.

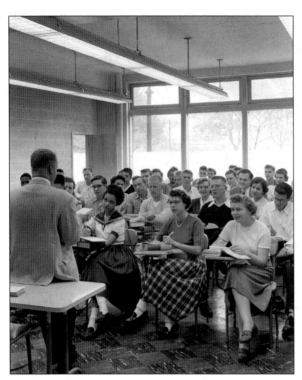

History Professor Joseph Ink (1954–1987) leans against the table as he lectures and his class takes notes in the winter of 1959.

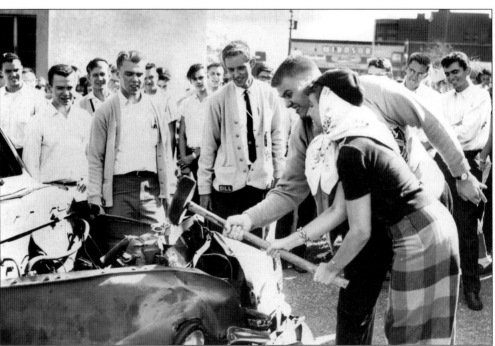

Freshman Day 1959 featured a new fad on college campuses across the country: students taking turns smashing a worn-out automobile with a sledgehammer until it was just a heap of metal. Here junior Robert Martin assists freshman co-ed Dorothy Novak in taking her turn battering the car.

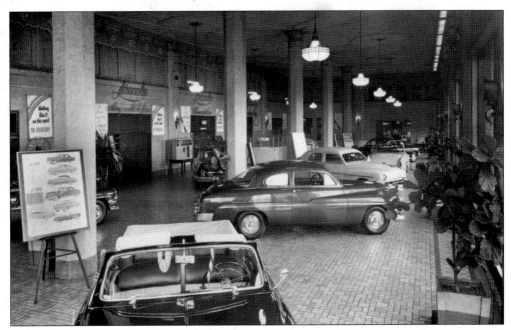

New 1951 Mercury automobiles are on display in the new car showroom in the Ohio Motors Building. In May of 1953 Fenn purchased the building for approximately $1 million. After it was remodeled, the showroom became the school's main cafeteria.

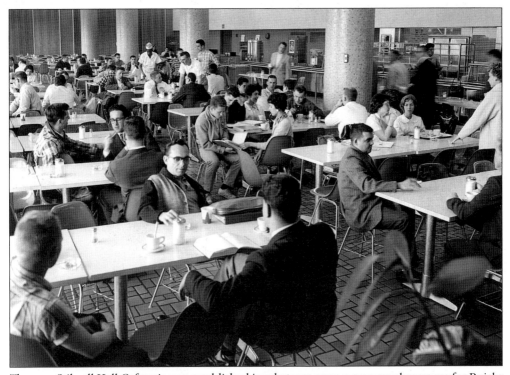

The new Stilwell Hall Cafeteria was established in what was once a new car showroom for Buicks and Mercurys. Notice in this 1959 image that the tile floor has been kept.

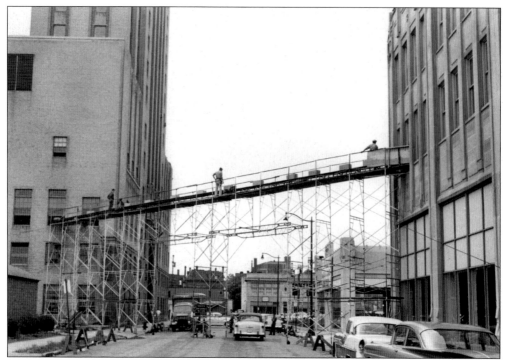

In September of 1959 the library moved from the third floor of Fenn Tower to the third floor of the recently renovated Stilwell Hall. By constructing a walkway on scaffolding across East 24th Street the Library was able to make the move without tying up traffic and avoiding the need to use the buildings' elevators.

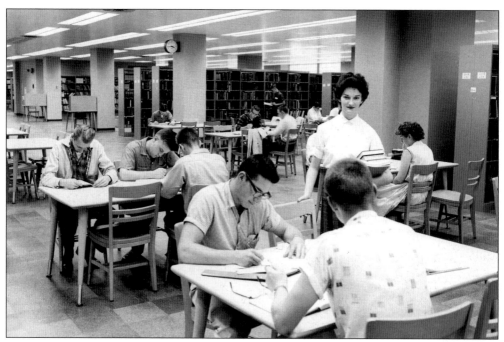

The third floor of Stilwell Hall was Fenn College Library's third home, seen here in fall 1959.

Radio station KYW personality and master of ceremonies for Fenn's Fifth Annual Homecoming, Dick Reynolds eats dinner with the Homecoming Queen candidates and their escorts before the Friday night pep rally, November 6, 1959.

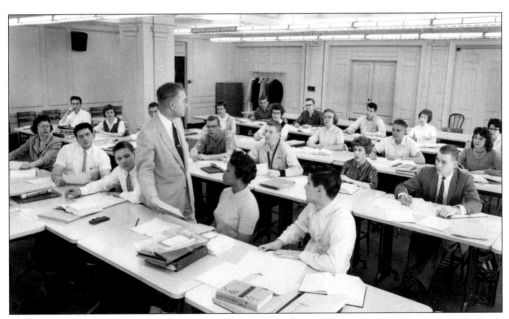

Accounting Professor Wilfred Ahrens (1954–1975) teaches a general accounting course in Fenn Tower, *c.* 1959.

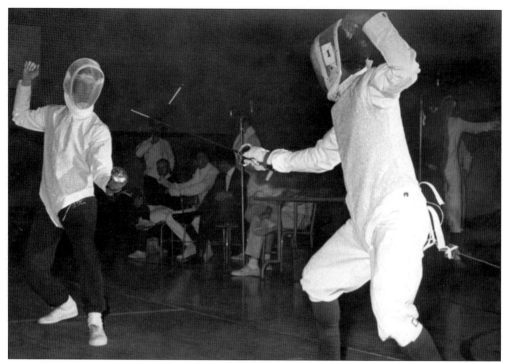

The formation of the Fencing Club in 1948 led to the restoration of fencing as a varsity sport in the early 1950s. One of the sport's highlights for Fenn came with the visit of Notre Dame University during the 1959–1960 season. Although the Fenn team lost the match 15–12, it made a strong showing in winning the épée matches by the score 8–1.

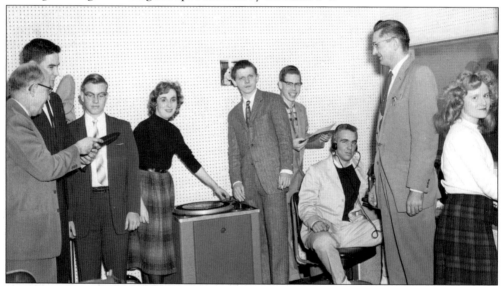

The Fenn College Radio and Television Club was formed during the 1956–1957 school year to cultivate and develop at Fenn College an interest in all phases of radio and television production. Shown at the 1960 club meeting are Professor Kenneth Sherman, T. Lamont, Peter Suvak (B.E.E., 1963), N. Zuk, T. Simon, John Velek, Gary Gilbert (B.B.A., 1964), Speech Professor and Faculty Advisor Theodore Bilski (1956–1974), and Patricia Goebel.

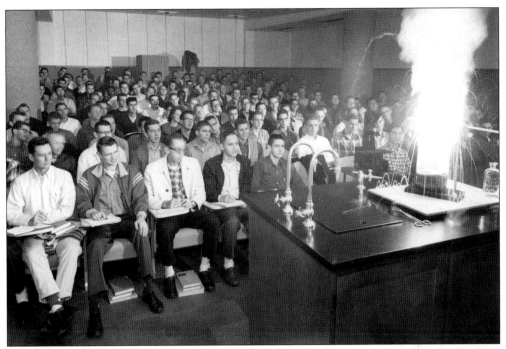

A demonstration showing a chemical reaction gets the full attention of a freshman General Chemistry lecture class in the new Stilwell Hall auditorium, 1960.

Chemistry students are pictured at work in the Chemistry Laboratory in the newly renovated Stilwell Hall, 1960.

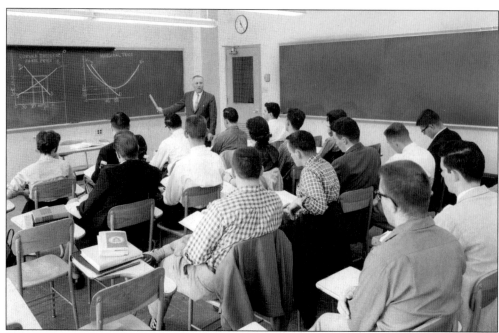

Economics Professor Demetrios Theodore discusses pricing with a principles of economics class in one of the new classrooms in Stilwell Hall, April 1960.

The Fenn College Bookstore was located on the first floor of Fenn Tower, as seen in this April 1960 photograph. The CSU bookstore would later move across Euclid Avenue into the Bell Motors Building.

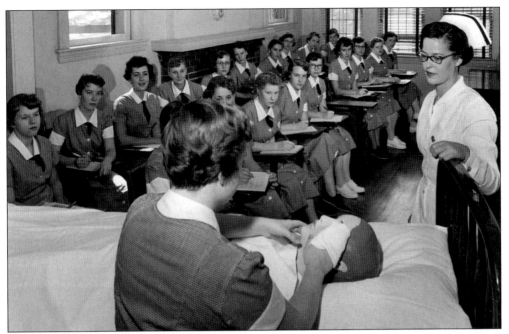

From 1954 to 1964 Fenn offered a nursing degree program in affiliation with the Huron Road Hospital School of Nursing. Here Margaret Woodworth R.N. (1954–1964), a nursing instructor, watches as Nancy Woods demonstrates a bedside technique on "Mrs. Chase," a mannequin patient, before a nursing class in Belmore Hall.

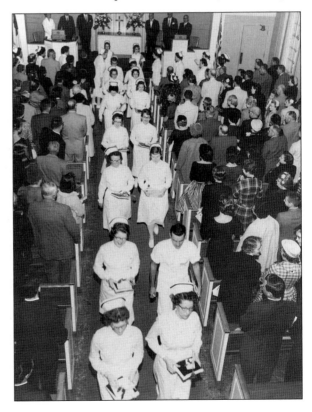

Graduates of the Huron Road Hospital School of Nursing's class of 1960 file out of the Forest Hills Presbyterian Church after receiving their degrees on September 15, 1960.

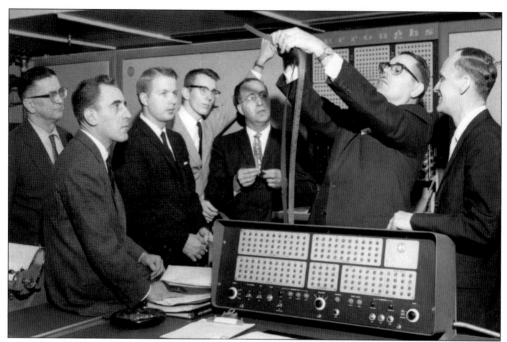

Fenn College's entrance into the "Computer Age" came about through an agreement with neighboring Arthur G. McKee Co., which allowed Fenn to install a new Burroughs 205 mainframe computer in an air-conditioned room in the McKee Building. Here faculty "computernauts" Michael Phillips, Michael Shuga, Francis McClarnon, William Taylor, Frank Gallo, Chester Kishel, and Ernest Harris inspect the computer at the McKee Building next door on Euclid Avenue, 1960.

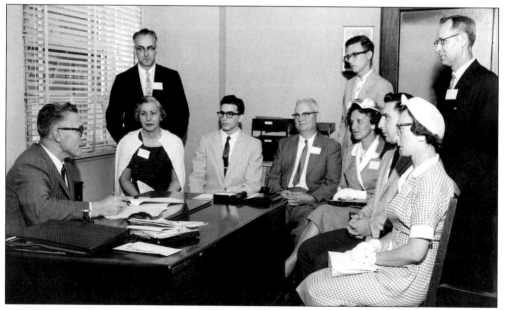

Tours of the college for students interested in attending Fenn included a meeting with Fenn's director of admissions. Here Director of Admissions Meriam Herrick (1938–1967) meets with three prospective students and their parents in his Fenn Tower office, July 1960.

Prior to coming to Fenn Dr. Lad Pasuit (1931–1962) was an instructor in the Flying Officers School in Austro-Hungary and a faculty member at the Royal Technical University in Budapest. A mainstay in the Chemistry Department for over 30 years , Dr. Lad Pasuit is shown teaching in one of the new classrooms in the renovated Stilwell Hall, 1960.

At the June 1960 Commencement, Fenn bestowed an honorary degree on Dr. George Heise, whose pioneering research in electrochemistry made possible the long-life dry cell battery. That fall Dr. Frank Bockhoff invited Dr. Heise back to lecture to his freshman chemistry class. Here Dr. Heise poses with Dr. Fred Sheibley, Elmore Pettyjohn (1958–1968), Dr. Bockhoff, and Dr. Lad Pasuit of the Chemistry Department.

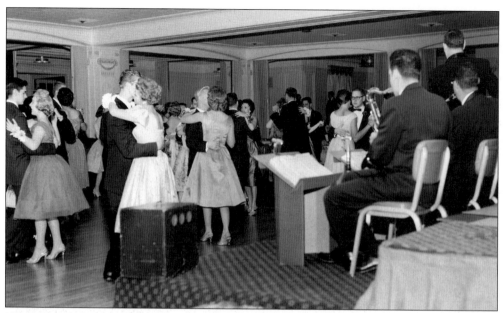

The Tau Kappa Epsilon fraternity played host to the 24th Annual Harvest Prom at the Rainbow Room of the Hotel Carter on October 28, 1960. Music was provided by Wes Harrington and his band. The Harvest Prom was traditionally Fenn's first major dance of the school year where the homecoming queen candidates were formally introduced.

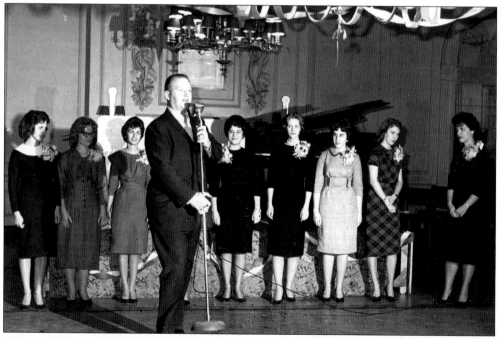

Fenn's Sixth Annual Homecoming Dance was held on November 12, 1960 at Cleveland Engineering Society Building. Master of ceremonies was radio station KYW personality Big Wilson, and music was provided by Billy Lang's big band. Here MC Wilson introduces the Homecoming Queen candidates before the start of the voting.

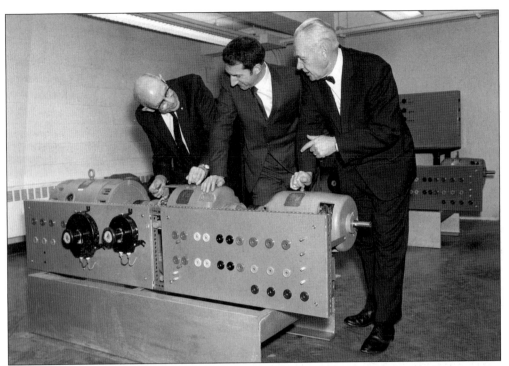

Electrical Engineering Professor Kenneth Sherman (1926–1972), Assistant Dean of Engineering William Kerka (1961–1980, B.M.E., 1948), and Electrical Technician William Mitchell examine new electrical motors in the Stilwell Hall Electrical Engineering Laboratory, 1961.

Lewis Turco (1960–1964), English instructor and director of the Fenn College Poetry Center, and guest authors and poets, Loring Williams and James Weil, discuss writing poetry during the second term of Mr. Turco's creative writing class, 1961.

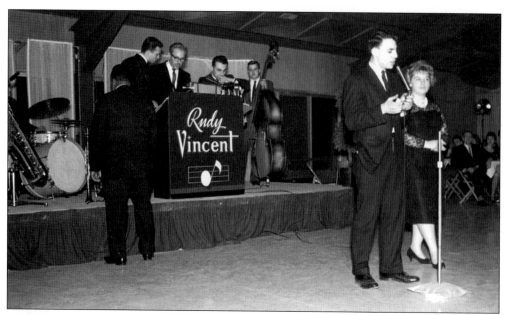

The Fourth Annual Satellite Swirl Dance was held on January 21, 1961 at the Aristocratic Riviera Swim Club with music provided by Rudy Vincent and his band. At the microphone is Vice President Vincent DiFranco (B.B.A., 1962) of Lambda Tau Delta fraternity and President Joanne Spataro of Iota Tau Lambda sorority, both representing the two sponsors of the event.

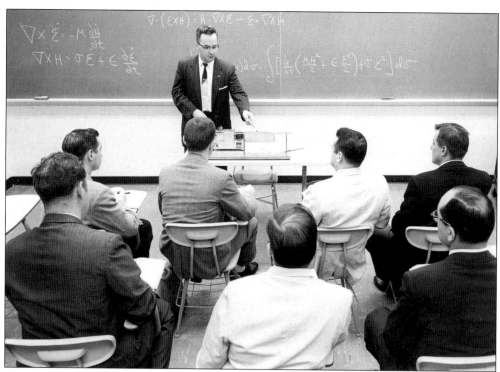

Assistant Professor James Maisel (1958–1965) instructs an evening mechanical engineering class during the spring term of 1961.

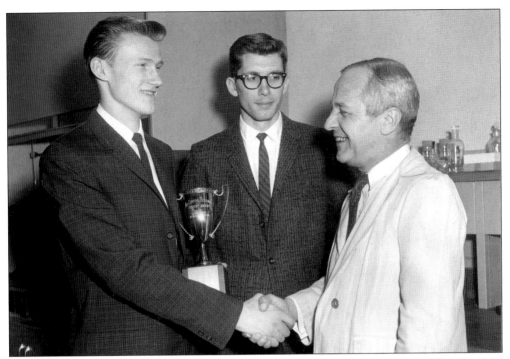

Chemistry Professor Dr. Fred Sheibley (1955–1971) congratulates seniors Roman Zorska (B.S., 1961) and Lawrence Wittenbrook (B.S., 1961) for winning the best student laboratory research paper award at Marian College in Indianapolis, Indiana, during the Mid-Central region convention of American Chemical Society's Student Affiliates, April 28–29, 1961.

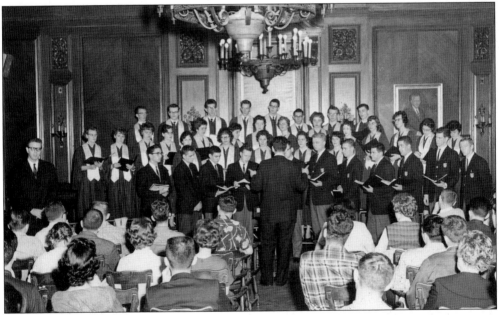

Music Professor Julius Drossin (1956–1984) conducted the combined Fenn Choir and King's Men in the concert, *History of the Civil War in Song*, in April 1961. The program, arranged and directed by Dr. Drossin, included commentary presented by Bill Randle of the History Department.

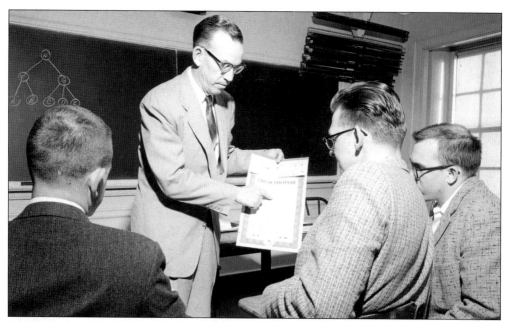

An expert in consumer economics and price theory, Dr. John McGrew (1945–1968), correlated Fenn College studies on the impact of St. Lawrence Seaway on the Port of Cleveland and land use in southeastern downtown Cleveland. Here Professor McGrew discusses government regulation of business with his economics class during the 1961 spring term.

Bernice Wotawa, an employee of Warner & Swasey Co., was the first woman to complete a certificate program at the Fenn College Technical Institute. Here Technical Institute Director Nicholas Rimboi (1937–1976, B.S.E.E., 1934) presents Ms. Wotawa with her machine design program certificate. This image dates to May 1961.

In the Athletics Office in Fenn Tower 503, Athletic Director Homer Woodling is on the right, and varsity baseball and basketball Coach James Rodriguez (1959–1994) is on the left, *c.* 1961.

In 1953 an advisory committee appointed by President Earnest recommended that the college establish an archive to house its permanent records and maintain a collection of college publications and memorabilia. Dr. Earnest appointed retiring faculty member George Simon as the college's first archivist. Mr. Simon is shown here with the Archive's secretary, Ethel Hamilton, in the new Archives area in the Stilwell Hall Library, November 1961.

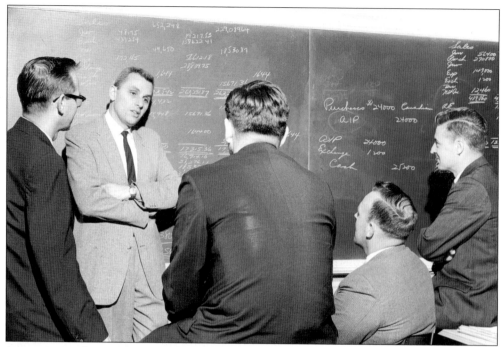

Accounting Professor Sidney Paul (1960–1985) discusses accounting problems after class with his evening division accounting class, 1961.

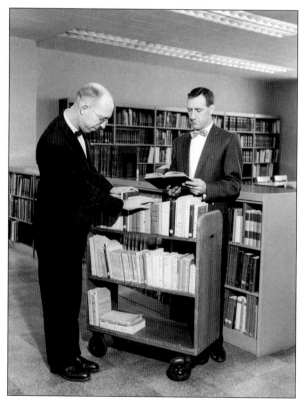

Modern Languages Professor Richard Small (1946–1984) and Library Director Emil Stefancic (1941–1983) look over new foreign language acquisitions for the Fenn College Library on the third floor of Stilwell Hall, April 1962.

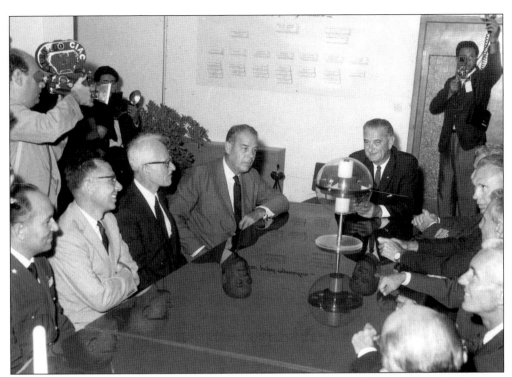

From 1961 to 1962 Dr. DeMarinis (1946–1977) served as deputy scientific attaché to the director of the American Space Project at the American Embassy in Rome, Italy. Dr. DeMarinis is seated second on the left at this 1962 meeting of U.S. and Italian space agency officials in the U.S. Embassy in Rome. That's U.S. Vice President Lyndon Johnson at the head of the conference table.

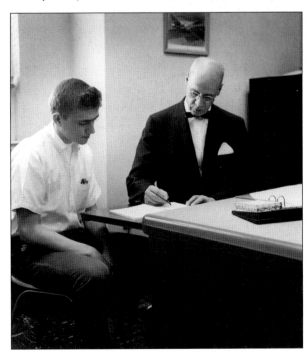

Cooperative Education Department Director Robert Auld (1946–1970) designs a co-op schedule for business administration student Terry Porter (B.B.A., 1966) in this photograph from April 1962. Mr. Auld spent 24 years working in Fenn's Cooperative Education Department and succeeded Max Robinson as director in 1960.

Modern Languages Professor Dr. Ella McKee (1957–1973) is pictured with a beginning German class in Stilwell Hall, May 1962. Dr. McKee also served as Fenn's third dean of women, 1962–1966.

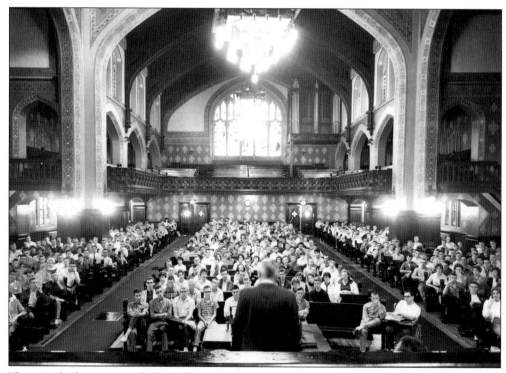

This view looks out towards the audience at Fenn's 41st Convocation Assembly at First Methodist Church, Euclid Avenue and East 30th Street, October 2, 1962.

On October 15 the opening speaker in Fenn's 1962–1963 lecture series was Ohio Governor Michael DiSalle. Speaking on the subject "The Future of Education in Ohio," the Governor commented that for some reason the state seemed to put little stock in the value of education and that if nothing was done about the problems in education the outlook for the state may not be bright.

Dr. Arnold Tew (1961–1993) came to Fenn College as an assistant professor of English and soon went into administration, starting as an assistant dean and eventually becoming vice president of Student Services at CSU. Here Dr. Tew is presenting a lecture to a freshman English class, 1962.

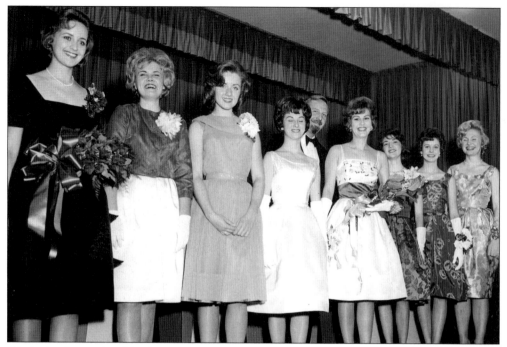

Skitch Henderson, band leader on television's *The Tonight Show*, was master of ceremonies at the Eighth Annual Fenn College Homecoming Dance at the Hotel Sheraton-Cleveland, November 3, 1962. Here he introduces the Homecoming Queen and her court: Ilga Krumins (B.A., 1965), Nancy Hyppa, Janet Daugert, Faith Tuttle, Carol Ann Drabik, Lucy Kamps, Patricia Hraback, and Jane Berry.

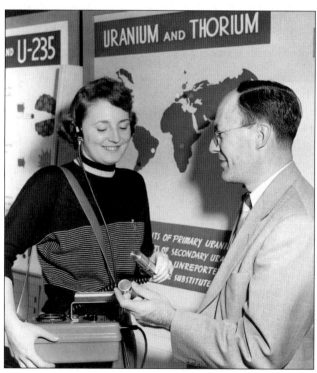

Dr. Harold Morgan (1937–1974) spent 37 years in the Physics Department at Fenn College and CSU. Here he shows Judy Riley how to use Geiger Counter, *c.* 1962.

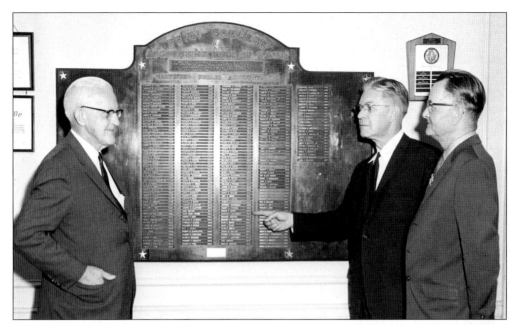

The wooden and brass Fenn College Accounting Roll of Honor plaque was a gift to the college from the J. Clytel Manufacturing Co. On it were listed the names of Fenn graduates who became Certified Public Accountants. In this 1963 image Business School Dean Paul Anders (1930–1965) and Accounting Professors Wilfred Ahrens (1954–1975) and John Froebe (1946–1965) look over the more than 250 names on the plaque.

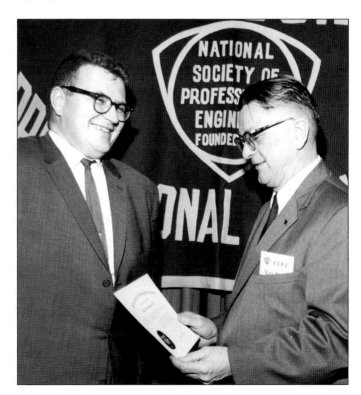

Civil Engineering Professor Michael Phillips presents Glen Drellishak (B.E.E., 1961) with the National Society of Professional Engineers Award after Mr. Drellishak finished first of 113 candidates in the State's 1963 Electrical Engineers examination.

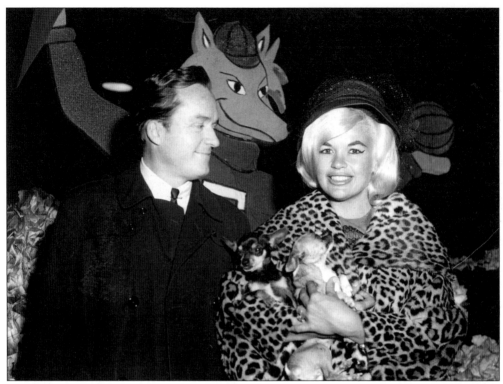

Actress Jayne Mansfield and Mike Douglas, who originally started his syndicated daily television program, *The Mike Douglas Show,* from television station KYW, Channel 3, in Cleveland, were the guests of honor at the 1963 Fenn College Homecoming, November 9, 1963.

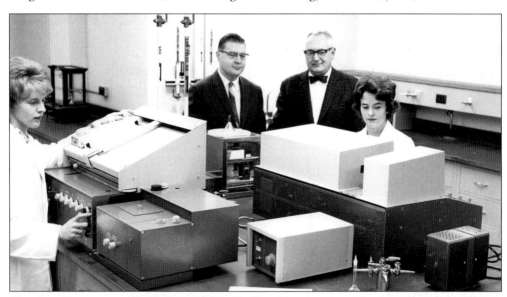

Chemistry Department Chairman Frank Bockhoff and Engineering School Dean Burl Bush watch as JoAnn Hromi and Lillian Kokenyessy operate the Beckman Infrared Spectrophotometer in the Stilwell Hall Instrumental Analysis Laboratory, November 1963. Dr. Bush served as dean of Engineering twice: 1936–1941 and 1962–1972

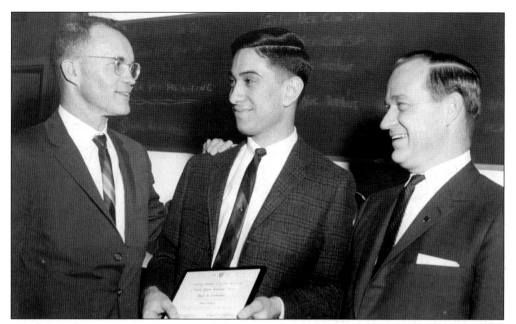

Dr. John Cumming (1956–1975), chairman of the Chemical Engineering Department, and Donald Dahlstrom, president of the American Institute of Chemical Engineering, present sophomore David Corbissero (B.S.Ch.E., 1966) with the 1964 AICE Outstanding Academic Achievement Award.

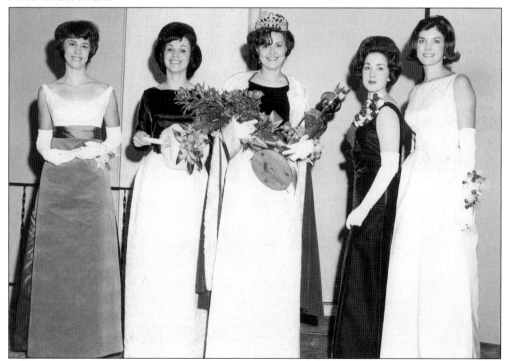

Joan Petrulis had the distinction of being chosen as Fenn's last Homecoming Queen at the Homecoming Dance, October 31, 1964. Pictured here are Joyce Vander Kayy, Phyllis Nawalanic, Joan Petrulis, Mandy Loundon (B.A., 1965), and Carol Wrentmore.

Twenty-four years after being the keynote speaker at Fenn's second mock presidential nomination convention, United States Senator Stephen Young returned to Fenn College on November 1, 1964 as part of the college's fine arts and lecture series.

Chemistry faculty Dr. Alan Rhodes (1962–1976), Dr. Bruce Turnbull (1963–1985), and Dr. Frank Bockhoff (1951–1989) engaged in research in the Stilwell Hall Chemistry Laboratory, 1964.

Management and Labor Relations Professor Harry Loudon, a former federal mediator, brings reality to the collective bargaining process for his Unionism and Collective Bargaining class. The class, divided into "management" and "labor," meets with federal mediator Edward O'Brien at the U.S. Mediation and Conciliation Offices as a strike deadline looms, in an attempt to reach a bargaining agreement, December 1964. (Photograph by Paul Tepley.)

Students are pictured working in the Mechanical Engineering Laboratory in Stilwell Hall, 1965. (Photograph by Glenn Zahn.)

Dr. Albert Cousins (1951–1988) of the Sociology Department chats with Fenn students Kathleen Kovach and Donald Obusek (B.B.A., 1968) between classes, January 1965. (Photograph by Glenn Zahn.)

George Parmelee (B.S.M.E., 1933) was an early expert in the field of solar energy. In between two stints on the Fenn faculty, 1938–1945 and 1963–1972, he worked for the American Society of Heating, Refrigeration and Air Conditioning Engineers and Arabian American Oil Co. in Saudi Arabia. Here Professor Parmelee works with subsonic wind tunnel in the fluid dynamics laboratory, c. 1965.

The Fenn faculty crowd the Stilwell Hall auditorium during the Special General Faculty meeting held April 17, 1965 to discuss the agreement with the Cleveland State University Board of Trustees to transfer operations of the college to the State of Ohio.

This view looks out from the speakers' table at the "Farewell to Fenn" dinner, held for the college's faculty and staff at Statler-Hilton Hotel on June 11, 1965.

It was a Fenn tradition for the college president to hold an informal reception in Panel Hall during the afternoon of commencement day for the senior class, their families, and friends. President and Mrs. Earnest are at the far end of the receiving line, and Provost William Patterson stands at the head of the line next to Mr. and Mrs. Paul Anders, June 13, 1965.

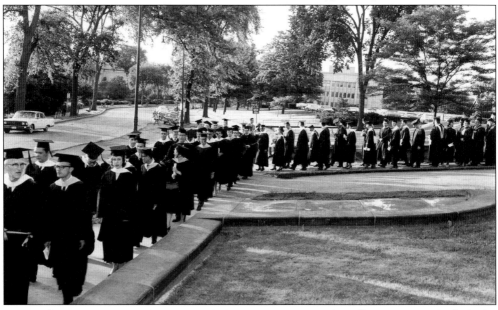

Fenn's last commencement procession enters Severance Hall, June 13, 1965. The Commencement Address was delivered by Fenn College Trustee Clayton Hale (B.B.A., 1932), and honorary degrees were presented to Harry Burmester, Edward Bartlett II, James Hodge, Vollmer Fries, Karl Bruch Jr., Paul Anders, Dr. William Patterson, and Dr. G. Brooks Earnest.

William Franz (B.B.A.) and his daughter Patricia Franz (B.B.A.) pose outside of Fenn Tower with Fenn President G. Brooks Earnest. Mr. Franz was a member of Fenn's first graduating class in 1927, and Patricia was in Fenn's last graduating class in 1965.

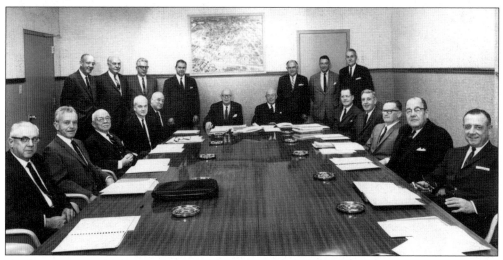

The last meeting of the Fenn College Board of Trustees was held on October 27, 1965. Pictured are the following: (seated) Arch Colwell, Ellwood Fisher, Howard Burns, Alan Rorick, Clayton Hale, Dr. G. Brooks Earnest, Harry Burmester, Karl Bruch, George Woodling, Vernon Davis, Vollmer Fries, and Walter O'Konski; (standing) Paul Dickey, Beauford Maxey, Alfred Hose, William Hunkin, Edward Helm, Edward Bartlett, and Galen Miller.

ALMA MATER

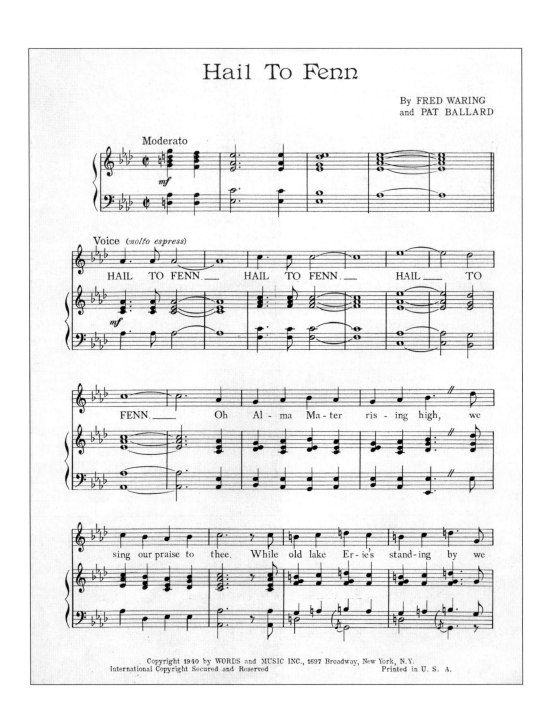

Hail To Fenn

By FRED WARING
and PAT BALLARD

Moderato

mf

Voice (*molto espress*)

HAIL TO FENN.___ HAIL TO FENN.___ HAIL___ TO

mf

FENN.___ Oh Al - ma Ma - ter ris - ing high, we

sing our praise to thee. While old lake Er - ie's stand - ing by we

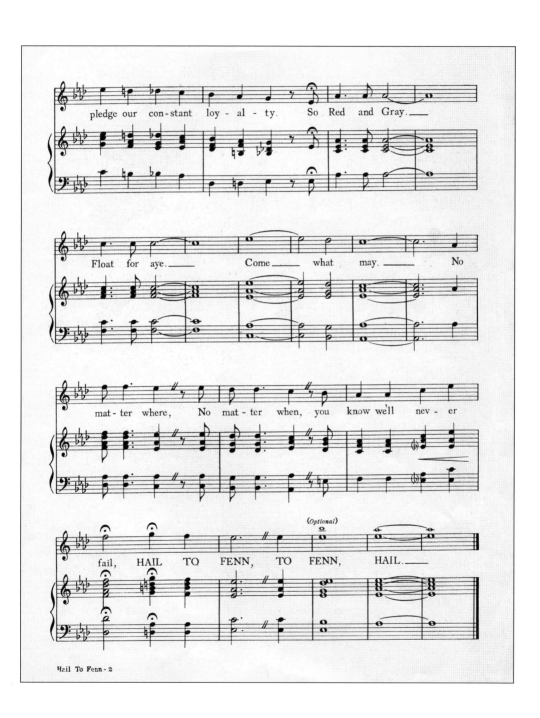

pledge our con-stant loy-al-ty. So Red and Gray.___

Float for aye.___ Come___ what may. ___ No

mat-ter where, No mat-ter when, you know we'll nev-er

fail, HAIL TO FENN, TO FENN, HAIL.___

(Optional)

Hail To Fenn - 2

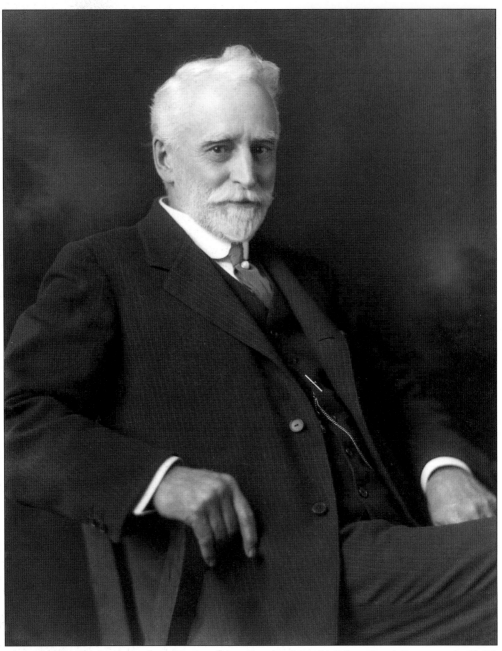

Sereno Peck Fenn was the benefactor of the Cleveland YMCA Educational Program, April 25, 1844–January 3, 1927.